On the Coast Guard Commandant's Recommended Reading List for Leadership.

"Theresa Barbo vividly recounts the heroic actions of the Pendleton rescue with insight from the heroes themselves, while paying tribute to the training and professionalism of the entire Coast Guard family."

—Congressman William Delahunt, Tenth Congressional District, Massachusetts

"A 36-foot motor lifeboat and its four-man crew were dispatched into the night and the storm from the Coast Guard Station at Chatham. As its coxswain, Bernard Webber recalled, they located the Pendleton in the dark only by 'this rumbling, crashing, banging sound over the wind and the sea.' Maneuvering boldly, the Coast Guard lifeboat rescued 32 of the crew, a mission ably recounted by Theresa Mitchell Barbo of the Cape Cod Maritime Research Association."

—*Boston Globe*

UPDATED THIRD EDITION

THE
PENDLETON
DISASTER
OFF CAPE COD

THE GREATEST SMALL BOAT RESCUE
IN COAST GUARD HISTORY

A True Story

THERESA MITCHELL BARBO &
CAPTAIN W. RUSSELL WEBSTER, USCG (RET.)

FOREWORD BY ADMIRAL THAD ALLEN (RET.),
CG36500 ESSAY BY MASTER CHIEF JOHN "JACK" DOWNEY (RET.)

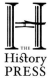

THE
History
PRESS

Published by The History Press
Charleston, SC 29403
www.historypress.net

Front cover: On February 20, 1952, two days after a nor'easter snapped the T2 tanker *Pendleton* in two, Richard Kelsey photographed the hulk off Chatham, Cape Cod. CG Station Chatham's cook, Fred Wahrenburger, and another crewman look on.

Back cover: The *36500* Gold Medal crew outside Station Chatham in May 2002. *Courtesy of Bernard C. Webber.*

First published 2010

Manufactured in the United States

ISBN 978.1.60949.050.8

Library of Congress Cataloging-in-Publication Data

Barbo, Theresa M.
The Pendleton disaster off Cape Cod : the greatest small boat rescue in Coast Guard
history / Theresa Mitchell Barbo and W. Russell Webster.
p. cm.
Includes bibliographical references and index.
ISBN 978-1-60949-050-8
1. Pendleton (Tanker)--History. 2. CG36500 (Lifeboat)--History. 3. Shipwrecks--
Massachusetts--Chatham--History. 4. Survival after airplane accidents, shipwrecks, etc.--
History. I. Webster, W. Russell. II. Title.
G530.P418B38 2010
910.9163'46--dc22
2010028293

To my husband, Daniel, and our children, Katherine and Thomas: thank you for your continued support, encouragement, love and good cheer!

—◦◦◦—

To my wife, Elizabeth, who taught me to write and think like a reporter. To my son Andrew and daughter Noelle, who inspire me with their talents, energy and passion.

—◦◦◦—

To our friend
In Memoriam
Bernard C. Webber
1928–2009

And to the memories of
Ervin Maske
1929–2003

Richard Livesey
1930–2007

CONTENTS

FOREWORD

S mall boat operations are the DNA of the Coast Guard.

With only six years of service under his belt at the time of the 1952 rescue, the young boatswain's mate, First Class Bernard C. Webber, Bernie as he was fondly known, orchestrated one of the greatest Coast Guard small boat rescues in Coast Guard history, earning the Gold Life Saving Medal for himself and his crew.

For the Guardians there was no turning back. Bernie had committed the lifesavers, deciding early on either they all would live or they all would die. Their odds of survival were nearly zero. These young men formed a team under emergency conditions and instinctively knew what to do. They trusted their lives unto each other. They were all in the same boat.

Bernie knew how to create the art of the possible where none existed.

In the fifty-eight years that have passed since this story has been told, men and women of the U.S. Coast Guard can still find relevance with their own dynamic missions of today in the actions of these fine men. Guardians have been known to self-activate untapped reserves of selfless devotion and instinct within themselves to do the right thing at the right time for the benefit of others, strangers in their midst trapped in extraordinary circumstances beyond their control.

The Coast Guard's Capstone Doctrine explains our culture and principles of operation: clear objective, presence, unity of effort, on-scene initiative, flexibility, managed risk and restraint. These traits can be traced back to Alexander Hamilton's Letter of Instruction to the commanding officers of the first ten Revenue Marine cutters that continue to serve us today. They are reflected in the historic actions of leaders like Bernie Webber. This guidance along with the testimony within this book will help every member of the Coast Guard—active duty, reserve, civilian and auxiliarist—understand who we are, what we do and why we do it.

The Capstone Doctrine maps our organizational DNA and reveals the evolution of our Guardian Ethos. It provides a solid foundation so we can adapt our operational activities to meet the maritime challenges of the twenty-first century. I encourage readers to reflect upon Bernie's story as an example of a fundamental building block to educate and enhance their professional judgment in the face of mission demands.

I am enormously proud of Bernie Webber. My wife, Pam, and I were touched to be with his family at his memorial service and interment in Wellfleet, Massachusetts, on May 9, 2009. I was pleased to celebrate his life and be there to hand to his wife, Miriam, of fifty-nine years—whom he met on a blind date and married five months later—a ceremonial flag.

He was a dedicated service member, a man who loved his family above all else.

On the plane ride back from the service, I spoke with the master chief of the Coast Guard, Skip Bowen, now retired, about a timely subject, the naming of the next cutter class to replace the aging 110-foot Island Class patrol boats. The Sentinel class, Fast Response Cutters, offered a chance to name a fleet of ships that linked us to our past and connect to initiatives focused on our heritage like the creation of the Guardian ethos: I am America's Maritime Guardian. I serve the citizens of the United States. I will protect them. I will defend them. I will save them. I am their Shield. For them I am *Semper Paratus*.

Bernie's life embodied both the past and the future. After the rescue, he continued an active dialogue with Coast Guard men and women until his final days. He was a humble leader who did not seek the spotlight for his deeds but only modestly to help those still learning by making profound

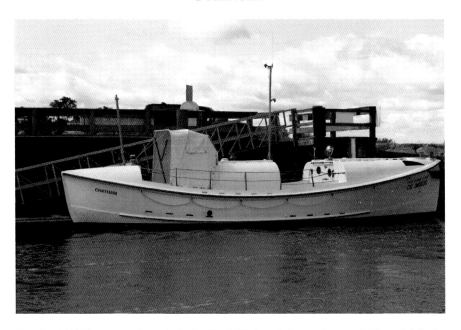

The CG*36500* in present times docked at Rock Harbor, Orleans. *Courtesy of Theresa M. Barbo.*

contributions to Coast Guard history through his articles, lectures and personal appearances. He spent countless hours with young Coast Guard men and women, participating in drills and exercises, recounting their rescues and providing constructive feedback. He championed the transition from the historic lifeboat of his time to the forty-four-foot motor lifeboats of the next era.

In April of 2010, I helped celebrate with Bernie's family the naming of the first 153-foot FRC in his memory. The *Bernard C. Webber* will soon set to sea. The Sentinel fleet, named in honor of our enlisted heroes, will still be in commission almost one hundred years after Bernie's famous rescue. By naming the cutters after Coast Guard heroes who were once enlisted, we "keep the focus on some significant people that influenced the Coast Guard…and means more than just those who received a lifesaving medal. It can encompass anyone, man or woman, who had a major, positive effect on the service," said Bowen, the immediate past master chief of the U.S. Coast Guard. "In some ways, like Bernie's self-effacing efforts to remain relevant and connected, the cutter will provide

a continuing connection to those Guardians who follow in his footsteps for generations to come."

The story of the *Pendleton* search and rescue, one of the most heroic cases in the U.S. Coast Guard's history is recounted within the pages of this illuminating book. Live they did, rescuing thirty-two of the ship's crew and returning to port to offer timeless leadership lessons from the past that are relevant for today's Coast Guard.

Thad Allen, Admiral, USCG (Ret.)

PREFACE TO THE THIRD EDITION

On February 18, 1952, the Coast Guard saved or assisted seventy of eighty-four merchant seamen from two Type T2 tankers that had broken apart off Cape Cod; the tankers *Pendleton* and the *Fort Mercer*. All told, twenty-four Coast Guard rescuers would receive accolades for their heroics.

Incredibly, five Gold Lifesaving Medals, four Silver Lifesaving Medals (for slightly lesser acts of heroism) and fifteen other awards would be given out in May 1952 to recognize this extraordinary day in Coast Guard history. In context, since its renaming in 1882 (previously established by the 1874 Lifesaving Act of Congress), the Coast Guard's Gold Lifesaving Medal has been given out, on average, only five times—in an average year.

In August 2007, the Coast Guard recognized the *Pendleton* rescue as its third most significant rescue since the service's origins as the Revenue Marine in 1790. Only the Katrina rescues of 2005 and the 1980 rescue of hundreds of passengers off the sinking liner *Prinsendam* in Alaskan waters was deemed to eclipse the *Pendleton* rescue. Hence, since only the *Pendleton* rescue included a small boat as its focus from among these top

three rescues, my co-author and I have aptly coined it the Greatest Small
Boat Rescue in Coast Guard History.

Captain W. Russell Webster, USCG (Ret.)

⁓

This true story captures the essence of primeval leadership, devotion to
duty and what it means to function at the highest ceilings of human grace
and grit in seemingly hopeless, emergency conditions.

Theresa M. Barbo

ACKNOWLEDGEMENTS

To Andrew "Andy" Fitzgerald, a CG*36500* Gold Medal Shipmate, who generously shared his memories of the historic mission of February 18, 1952, with co-authors Barbo and Webster.

Our thanks to Mrs. Pattie Hamilton, daughter of Bernie Webber, and Mrs. Anita Jevne, Ervin Maske's daughter, for their assistance.

We are grateful to Admiral Thad Allen for his compelling foreword, and we thank Commander Martha LaGuardia-Kotite for her sage advice and input. Our colleague, Master Chief Jack Downey, retired, composed a beautiful essay about the CG*36500*, and we thank Jack for his contribution.

Also, our thanks are extended to Dr. Robert Browning, USCG Historian, and Scott Price, of the Coast Guard Historian's office, both of whom were instrumental in providing the authors with important information. New images added to our third edition are thanks to Public Affairs Petty Officer Second Class Elizabeth Bordelon from Coast Guard District Eight, and Public Affairs Petty Officer Second Class Lauren Jorgensen and Public Affairs Petty Officer Second Class Etta Smith from Coast Guard District One. As always, we are indebted to Senior Chief Bosun's Mate David Considine for sharing information about Bernie.

We would be remiss without thanking Richard Hiscock for his continuing support.

The incomparable team at The History Press is second to none: Managing Editor Julie Foster, Sales Manager Brittain Phillips, Publishing Director Adam Ferrell, Commissioning Editor Jeffrey Saraceno, Project Editor Amber Allen, Editorial Department Manager Hilary McCullough, Senior Designer Natasha Momberger, Katie Parry in public relations and Dani McGrath in sales.

INTRODUCTION

Their names have become a part of history: Ervin Maske, Richard Livesey, Andy Fitzgerald and Coxswain Bernie Webber.

The true story of the Coast Guard mission in which thirty-two merchant mariners were rescued by four young Coast Guardsmen aboard the intrepid CG*36500* motor lifeboat on February 18, 1952, should have ended the night it began, neatly tucked away in a manila folder at Coast Guard headquarters. After all, it was just another mission completed under harrowing weather conditions. Lives saved. Tragically, one life lost—on to the next case.

Yet this specific rescue mission of the crew of a foundering oil tanker, the 503-foot *Pendleton,* led by Coxswain Bernie Webber from the Chatham Lifeboat Station continues to captivate, inspire and enrich nearly all who hear it fifty-eight years later.

Our book is about the heroic Coxswain Webber and the aftermath of the rescue and how it affected his life. "It's been a nightmare for me," he once told us, and added that being called a hero was a "life wrecker." And because leadership means knowing when to follow, it's also the story of superbly trained merchant mariners, part of this nation's fourth arm of defense, who knew how to take orders and operate as a hastily assembled, yet cohesive team, during an emergency.

For me this journey began in 1999. I am the founder of the annual Cape Cod Maritime History Symposium, now in its fifteenth year, and in partnership with the Cape Cod Museum of Natural History, one of the few symposia in New England. Each year, four to five topics are presented by authorities in their field. One topic that year was the CG*36500* rescue of the *Pendleton* crew, presented by a retired Coast Guard reserve commander by the name of Robert F. Weber (no relation to Bernie). I had never heard of this famous rescue and was curious about it myself. My research niche for the past twenty years has been the merchant marine, so to learn more about twentieth-century merchant mariners would be interesting.

A few days before the symposium my kitchen phone rang. On the line was Captain Russ Webster, Group Woods Hole commander, and he asked if he could come and hear the lecture on the CG*36500*. Was it too late to register? I said certainly not, and we met for the first time at that event. Captain Webster had a particular interest in the CG*36500* that you'll read about in a moment. He is a historian specializing in Cape Cod Coast Guard rescues.

A year later, in 2000, Captain Webster delivered an illustrated presentation at the symposium called "Nearly Forgotten: the Sinking of the Vineyard Lightship #73, September 1944." Shortly afterward, Captain Webster became chief of operations for Coast Guard District One in Boston.

The world of Cape Cod maritime history resembles a small town and we all have our special niches and interests in which we research and write. In some ways, it's a fraternity with folks sharing data, images and scraps of information that may prove useful in our respective work. The captain and I stayed in touch about maritime history research, and Captain Webster mentioned in late 2001 that he was interested in reuniting the crew of the CG*36500*.

There could have been a reunion, yes, but having the original vessel enhanced the range of events for the three-day series of events in Boston and on Cape Cod.

Here's the back-story: the CG*36500* was found rotting in a salvage yard by Bill Quinn of Orleans who launched an aggressive, successful campaign

to salvage, restore and operate the vessel. Following Quinn's tenure, Pete Kennedy of Orleans took over, and these days the responsibility is shared between Don Summersgill and Richard Ryder. It's amazing how deeply and strongly people have attached themselves to this alchemy of wood and metal, as if the boat was its own person. But the loyalty factor to the *CG36500* is wide and sustained. Today, the Orleans Historical Society owns the *CG36500*, but the chances of the vessel ending back in the hands of the Coast Guard, probably at the Coast Guard Museum in New London, Connecticut, remain high.

In any case, anticipating reunion events would most likely occur down on Cape Cod, and Captain Webster was headquartered in Boston, I offered to assist with anything that needed being done in Chatham. We formed a working committee that included Bonnie and Stanley Snow of Orleans, Bill Quinn of Orleans, Donnie St. Pierre of North Chatham, the late Parker Wiseman of Chatham, Chatham Selectman Douglas "Dougie" Bohman and Donna and Bob Weber of Orleans, dear friends of the Snows. The volunteer work proved challenging, but we forged ahead and helped make the three-day reunion a success.

For my co-author, Captain Webster, the first task before the working committee could begin was to convince Bernie Webber to agree to the reunion. When Captain Webster approached Bernie about the reunion, Webber had understandable reservations. "Very much so, because I wasn't sure what his motivation was, what he was thinking," Webber remembered in 2002. "I didn't think it was a very good idea at first, but as he talked to me, he finally said to me, 'Under what conditions would you agree to it?' and I said, 'All right, let's talk about it.'"

Bernie's first question to Captain Webster was "Would such an affair be good for the Coast Guard?" Webster answered, "It would." Bernie's first condition was that all four Gold Medal crewmembers had to attend. "If one couldn't make it, forget it," he said to Captain Webster. A second condition was that "unlike fifty years before, the families would be allowed to be present; they would be invited," and Captain Webster said yes to that request, too.

This event would have to be a Coast Guard activity, unlike, in Bernie's words, "fifty years before when we went to Washington and not one Coast

Guard officer was present, only the 'beltway types' from Washington that go to these affairs." Webber remembered attending an event where he felt like a puppet to promote the Coast Guard, hence the cynicism. Captain Webster assured Bernie a reunion "wouldn't cost…money to participate in the event. Our ways would be paid," which was the fourth condition. Captain Webster agreed to all of it.

After reassurance by Captain Webster, Bernie told him, "I'll try to persuade the other fellas." Agreeing to the conditions was the easy part; now Captain Webster had to find the former Coast Guardsmen. Bernie and his wife, Miriam, had retired to Melbourne, Florida; Ervin had settled in Marinette, Wisconsin. The Coast Guard found Richard Livesey in Florida not far from Bernie, and he brought his wife, Virginia, to Boston. Andy Fitzgerald and his wife, Gloria, flew in from Colorado. A widower, Ervin Maske was accompanied by his devoted daughter, Anita Maske Jevne, and son, Matt.

Then one thing led to another, as the adage goes. After the reunion that is detailed in a later chapter, Captain Webster and I began work on the first edition, which was launched in August 2007. The first edition contained three supplementary chapters skillfully composed by historian John J. Galluzzo of Hull that complemented our chapters on the mission itself. John's fine work included the birth of motor lifeboats, the first lifesavers and what New England was like in 1952, giving the first edition a breadth of needed context. The second edition was published in October 2008, but with new information about the mission available and a limited word budget; John's earlier work was omitted. At the same time we decided to donate all author proceeds to the Cadet Activities Fund at the Coast Guard Academy, ridding the project of personal profit in the spirit of honoring our genuine friendship with Bernie.

We also wished to share our work and Bernie's story with young cadets and midshipmen, and after the second edition was launched, we were delighted to receive an invitation to present a lecture on leadership about the rescue at the Coast Guard Academy the following March at the invitation of then commandant of cadets, Captain John Fitzgerald. I said to Captain Webster, "I can't do this without you," to which he

replied, "*we* can't do this without Master Chief Downey," so the three of us hit the bricks and launched the CG*36500*–*Pendleton* Leadership Series, an illustrated presentation designed for listening audiences at service academies in New England.

I can't begin to tell you how special these visits are: the many people we meet, the bright faces of the cadets and midshipmen (and women) at these service academies, not to mention the beautiful campuses always by water, of course, and some with incredible maritime museums and libraries and ships. We volunteer our time and following our presentation in the auditorium, or a similar venue, our hosts feed us on their Mess Decks. When we dine at long cafeteria tables with cadets and midshipmen we are fortunate to share stories, answer their questions about Bernie and the mission, but mostly we learn about their future plans and dreams for themselves.

Bernie got a charge out of the Leadership Series and was pleased to see that his three friends—Captain Webster, Master Chief Downey and I—had developed a road show about his story. This Leadership Series couldn't exist without Captain Webster or Master Chief Downey. It's a success because we bring various experience, wisdom and perspectives to our work, and our diversity is what brings us together.

I see the Leadership Series as my way of serving my country, and it's a meaningful way to express my belief in, and to, this new generation of leaders coming of age that our country's proudest and best days are yet ahead of us. I proudly wear an American flag pin on my left lapel. Future leaders ride on the shoulders, as Jack Downey said it best, of Bernie Webber and others like him. In that category are the three Guardians aboard the CG*36500* with Webber: Andy Fitzgerald, Richard Livesey and Ervin Maske.

Bernie dropped me an e-mail promising to "put together a bit of information that you could use to 'woo' cadets…overlooked since 2002 is/was my Merchant Marine service." But Bernie never got the chance to come through on that promise, the only promise to me he had ever broken. He died four days later. I had lost one of my dearest, truest friends. And I miss him fiercely: his kind but gruff voice, his wise counsel, dry sense of humor and unfailing grace.

Webber wasn't shy about sharing his thoughts on the Coast Guard. In an e-mail exchange with Senior Chief Boatswain's Mate David Considine, a former officer in charge at Station Chatham, Bernie discussed what makes for a great coxswain. Here's part of that exchange in Bernie's words:

> *A coxswain must be a take charge type of guy/gal; must assume responsibility for the safe operation and navigation of a boat and its crew ever mindful of the limitations of both to assure the success of a mission; must be a leader and be able to give direction and see that orders are carried; without hesitation be able to make decisions based on circumstances. The occasion may arise in a life or death situation where a Coxswain may find he's all alone, no direction from shore, or any other ranking authority can save the day. Although the occasion may be rare he must be prepared and willing to make his decision. The boat Coxswain has an awesome responsibility not to diminish any crew members. It's up to the Coxswain to train and direct crew members instilling not only confidence in him but in themselves. He must remain at all times in charge.*
>
> *For what it's worth I pass this on for those who express a different view of what a Coxswain is and should remain.* Semper Paratus. *Bernie W.*

Those of us who knew Bernie well could envision the retired warrant officer saying those words!

To continue this story, we then got the green light from The History Press to move along on a third edition. And so here we are. And here you are, reading this. If someone had said to me that this story and my engagement in it would continue long after the 2002 reunion, that our book would be headed toward a third edition and form the foundation of an acclaimed lecture series, I might not have believed them. The first and second editions are on the Commandant's Recommended Reading List for Leadership and we have high hopes that the third will remain on that coveted register.

While not entirely sure where the compass of fate will lead us in the future as we tell the story of the CG*36500*, all I can say for sure is that it may be a long while before the story of the 1952 rescue reaches full circle. If it ever does.

Theresa M. Barbo
Yarmouth Port, Cape Cod, Massachusetts
August 2010

———

The beginnings of the idea for the 2002 fiftieth anniversary *Pendleton* reunion are a bit of a blur for me, muddled by the initiation of the idea amid the waning days of my command at Group Woods Hole in the spring of 2001. It was a hectic time with the prospects of a new duty station to Boston's First Coast Guard District as the district's chief of operations and thoughts of returning my family to our home in Cape Elizabeth, Maine.

These memories were later made even cloudier by the realities and time sink from the huge new responsibilities that came in the aftermath of the terrorist attacks of 9/11.

Few people understand the enormity of the water transport of some 750,000 New Yorkers from Manhattan, more than twice the number of people transported from Dunkirk that occurred in the days after the attacks. Few understand to this day the shape-changing nature of this event on Coast Guard roles and missions. As a result, the Coast Guard changed and adapted as it always had for the past 210 years to the new terrorist threat. My own life had changed with the exigencies of the war on terror that required one hundred work hours or more a week and a diet that saw me pack on forty pounds of North End blubber.

Yet through it all, I always knew the Coast Guard absolutely had to honor the fiftieth anniversary of the *Pendleton* rescue. It made sense to me that my venerable service should spend some modicum of time honoring its past heroes even as it charted entirely new courses for the future. I also

knew that the Coast Guard in 2002, especially its officer corps, was very different and welcoming of its past heroes, both enlisted and officer, than previous generations.

These were my heroes, my idols—men who had done incredible death-defying feats in the face of incredible pain and suffering with far less training and equipment than their modern counterparts; investing the time to plan the wide scope of the reunion was well worth the effort.

Though the Coast Guard cherishes its heritage today, earlier senior generations in the service had opted to forget them for almost a half-century, and it would have been easier for some of them to remain anonymous and not open old wounds and memories.

I had learned to depend on my senior enlisted leaders and much, much more from Master Chief Boatswain's Mate Jack Downey. Downey, during my tenure at Woods Hole, had gap-filled enlisted leadership voids in five different commands while I was the group commander. He was a leader who demonstrated his ability to simultaneously command one shore station while temporarily commanding a second station while leadership fixes were sought. He was a leader who, despite intimate familiarity with all manner of small boats at rescue stations, volunteered to fill in and command the new eighty-seven-foot cutter *Hammerhead* when its officer in charge hurt himself in a fall. Downey was an Old Salt steeped in tradition but unafraid to spice up his life with new challenges. And, he also had learned respect for the past from one of the finest gentlemen we both would come to know at Station Chatham.

I first heard about the heroic 1952 rescue of thirty-two *Pendleton* crewmen in 1998 shortly after becoming the Coast Guard's Group Woods Hole rescue commander responsible for the small multimission Coast Guard stations from Cape Cod to Newport. Master Chief Downey invited me to the Coast Guard Station Chatham to witness a ceremonial pinning of new chief petty officers, which to this day remains an indelible personal memory.

Pinning involves the ceremonial mixing of collar devices from seasoned chief petty officers with a new set of pins for the new chief in an overturned combination cap. The concept was that the experience and ideas of the new generation were symbolically melded with their

predecessors. It all made sense, except for the one extra set of devices given out that day. The master chief explained that the extra set of chief petty officer (BMC-CPO) devices, worn smooth with time, belonged to the coxswain of the thirty-six-foot rescue craft (then) Boatswain's Mate First Class (BM1) Bernie Webber—the inspiration for the tradition. His collar devices would go to the newest chief petty officer. Downey clarified that today's generations of guardsmen are truly "standing on their [CG*36500* rescue crews'] shoulders" when they don the treasured devices of the man from a bygone era.

And, so it went. That moment at Chatham and my subsequent attendance at the annual Cape Cod Maritime History Symposium that discussed the famous CG*36500* boat led me to research the 1952 rescue, finding Webber's own 1985 book as the sole source for documenting this remarkable rescue.

That research turned into a December 1999 US Naval Institute *Proceedings* article and the eventual concept for a May 2002 series of Boston and Cape Cod recognition events. My district commander, Rear Admiral Vivian Crea, and Tenth Congressional District congressman Bill Delahunt (himself a former Coast Guard reservist) readily agreed to participate in the series of events. And, the commandant's office in headquarters also agreed to reissue the Gold Medal crew's award citations for the 2002 ceremonies.

To date, more than twenty chief petty officers have worn Webber's CPO pins and carried on a tradition of respect that will likely perpetuate for generations to come. And, with time, this pinning tradition has become widespread. In the following years, I learned that there was more to the *Pendleton* rescue than met the eye: more heroics on many levels and more pain than there should have been for the four brave crewmen, especially Boatswain Mate First Class Webber. *The Pendleton Disaster off Cape Cod* does justice to the *Pendleton* rescue story and the brave men of CG*36500* that might not have been properly told were it not for the determined efforts of my co-author, Theresa Mitchell Barbo.

More than anything else about my relationship with Chief Warrant Officer Webber, I find myself emulating him in ways that only become clearer with the passage of time.

The reunion was, in retrospect, just a springboard for me to engage in my favorite past time—story telling—and in my own way through the Leadership Series to honor my good friend and mentor, Bernie. Each new crop of cadets or midshipmen, some exhausted from their normal routines, will, like me, perhaps only come to recognize the importance of what they are hearing several years later. Some get it right away, and you know a difference has been made. Others, it will take time. But, they all will hopefully understand a little bit more about what is possible by hearing about the impossible rescue of thirty-two seamen from the sinking *Pendleton.*

Captain W. Russell Webster, USCG (Ret.)
Cape Elizabeth, Maine
August 2010

Chapter 1

PASSAGES

Bernie Webber woke up on January 24, 2009, as a cold breeze ripe with the softer edge of a Southern winter blew over his house in Melbourne, Florida. Bernie tackled the morning with his trademark vigor. There were errands to run, e-mails to read, compose and send, a small yard to keep up and Miriam, his wife of fifty-nine years, to look after. Usually he'd hop on his golf cart that he used to ferry him and Miriam around their closely knit retirement community. Webber cooked, he cleaned and saw to all details of their long lives together.

For Webber, eighty, the plain-spoken retired mariner, all seemed normal that day in the simply crafted life Bernie had created for himself and Miriam. It was a peaceful existence, lived as the Webbers wished: fully, with the blessings of children and grandchildren, friends and with meaningful work left behind and restful days ahead. Though in the embrace of meaningful retirement, the Webbers were not in perfect health; both had quit smoking years before, but Miriam suffered from breathing difficulties and Bernie was a diabetic. Still, their lives were happy.

But by midnight, Bernie, one of the Coast Guard's revered heroes, would be dead.

Throughout the day, Bernie told Miriam "I'm just tired." By dusk, Bernie had slowed. That evening, Miriam and Bernie sat side by side in

their favorite chairs and watched television. About ten o'clock, Bernie went to bed.

Come nightfall, something went terribly wrong.

"Miriam, can you come in here? I'm not feeling too good," Bernie called to his wife. Miriam found Bernie restless and uncomfortable. Rarely through the years had this big man complained so Miriam knew something was not right. Lately, she'd seen Bernie rubbing his chest when Webber thought Miriam wasn't looking. "He never said a word to me about anything," Miriam remembered. But that night even Bernie agreed he was not well. She offered to phone the doctor but Bernie declined. "Just stay with me," he told her.

Miriam sat on Bernie's bed and rubbed his back for about fifteen minutes, slowly, her hands finding familiar niches and well-worn paths after of decades of marriage. All the while, sharp pains crawled across his chest. Miriam heard Bernie make some gurgling noises in his throat. "He lay down and put his head on his pillow and I told him he was mumbling, but then I realized he had already passed on."

Miriam looked into his eyes and saw the expired spark and blankness of death; his gaze had already retreated somewhere deep inside a well. "I looked at him and said, 'Oh, my God,'" she remembered. "I opened his eyes and I said, 'Oh, my God,' again, and the eyes just stared at me. I didn't get a pulse."

Bernie was dead, later it was learned of an apparent heart attack; Miriam thinks it was a blood clot. He, who stood sturdy and faced all manner of storms during a long life, including that nor'easter in 1952, had succumbed to a weak heart.

Miriam was devastated—and in shock. "I screamed a couple of times," Mrs. Webber said. "How can you do this to me?! How can you go?!"

With her husband lifeless beside her, Miriam reached for the phone and dialed 911. Miriam waited, growing cold in her flannel nightgown while sitting beside her husband for the last time with the sounds of sirens growing louder as paramedics and a sheriff's deputy approached the house.

Miriam would later insist Bernie died in the waning minutes of the 24th; it was just before midnight, Saturday night. And not on the 25th, as official records stated.

A friendly sheriff's deputy named Kevin stayed with Miriam until 2 a.m., long after Bernie's body was transferred to the morgue. (In the days following his death, Miriam decided to have Bernie cremated and his ashes interred on Cape Cod in spring.) After the ambulance left, needing to bear dreadful news, Miriam sat with the sheriff's deputy and called family and close friends. She dialed her son-in-law, Bruce Hamilton, a lieutenant colonel in the U.S. Air Force. Bernie and Miriam loved Bruce like a son, and he wore the title well and spent many years devoted to the Webbers.

It fell to Colonel Hamilton to tell his wife, Patricia "Pattie" Webber Hamilton, Bernie's cherished daughter, who was visiting her daughter, Leah, at Smith College in Massachusetts. Hearing that her father had died had brought Pattie to tears and misery. Even today, Bernie's passing remains a crushing blow to Pattie, in whom Bernie had a trusted confidante, devoted daughter and friend. And in the far reaches that grief can travel his death remains a wound that won't heal. "It is very surreal; I still feel like he's around," said Pattie. "I always feel he's around. I haven't gotten over that yet."

News of Webber's death traveled quickly, especially in Coast Guard circles. The office of then-Commandant Allen circulated a Coast Guard-wide communiqué to note Webber's death. E-mails and phone calls flew across the country. The national media picked up the story of a Coast Guard hero's passing, though Miriam insisted that no media in the Melbourne area be notified. Neither Bernie nor Miriam had discussed his famous Coast Guard rescue with anyone in their social or civic circles; such were their humble natures.

In the weeks following his death, it became clear that in keeping with his character Bernie left his affairs in perfect order. "Fortunately my dad was organized and even left us an outline of everything to do in the event of his death," Pattie said in an e-mail shortly after her father's passing.

Through the years, Chief Webber became an icon among the Coast Guard's community of Chiefs' Messes through their own earliest story telling about the 1952 rescue and in later years through Bernie's own personal engagement with the community of chiefs. The chiefs collectively and individually sought and received his counsel just as he had given the

ordinary seamen counsel during his annual summer pilgrimages back to the Cape and Station Chatham. Bernie maintained this connectivity and relevance that Admiral Allen speaks about in his foreword through phone calls and hundreds of e-mails between numerous correspondents. And the majority of the exchanges Bernie had with Coast Guardsmen had to do, in some related way, with his actions the night of the legendary rescue of the *Pendleton* crew. There are many with whom Bernie corresponded who felt the CG*36500* rescue was as timely as their daily newspaper.

FEBRUARY 18, 1952

Four young Coast Guardsmen drove from the Chatham Lifeboat Station to the fish pier across town in the late afternoon of February 18, 1952, barely speaking. Ervin Maske, Andy Fitzgerald, Richard Livesey and Bernie Webber were about to head into the fist of a nor'easter, a winter storm mariners fear most with high winds that wouldn't quit and cold that sent needles of pain seeping through skin to bone. This particular nor'easter would be one for the history books: up to thirty inches of snow fell across New England between February 17 and 18.

Only a trace of daylight was left of that miserable day when the four-man crew pulled up to the pier.

Their orders from an inexperienced officer in charge, Daniel Cluff, who'd barely set toes in salt water seemed reckless and impossible: locate the 503-foot oil tanker *Pendleton* that had split in two off Chatham, at the elbow of Cape Cod, which was in imminent danger of sinking, possibly with human lives at stake. Under normal conditions, Coast Guard crews train for hundreds of hours before this type of mission, but that evening Bernie had orders to cobble together a crew and search for the *Pendleton*, so for the first time these untested partners would venture out together.

Andy kept mum about his reservations. "Boy, we are to be wet and cold, and we were, but we were able to adjust to it," he remembered thinking.

Bernie's thoughts were with his young, sick wife, Miriam. "I had a real cold, flu-like" symptoms, she remembered in 2002, her vivid blue eyes alight with reflection and memory. "I felt lousy," so she stayed put at Silver Heels on Sea View Avenue in Chatham that she and Bernie had rented in 1951.

On the dock, Bernie ran into John Stello, a friend and local fisherman. "Call Miriam and let her know what's going on," Bernie asked him.

"You guys better get lost before you get too far out," Stello shouted. Stello's meaning was clear: "go hide somewhere until the storm passes or else you'll die."

It was 5:55 p.m.

This day seemed never to have an end.

Bernie and Richard, stationed at the Chatham Lifeboat Station, had already been out for hours. "We'd been out the whole time, the whole day, we knew how rough it was going to be out there, to tell you the truth, ya know, from looking at the shore out, you could see the waves breaking on the beach," Richard recounted. Andy had remained at Chatham for much of the day and Ervin was there, too, awaiting transport to the *Stonehorse* Lightship once the weather broke.

Earlier in the storm, the nor'easter had severed moorings that sent fishing boats on solo cruises in inlets and harbors. On Cluff's orders, Bernie and three other three Coast Guardsmen had headed to Old Harbor to take the *CG36500* and tow fishing boats back to their moorings. It was wet, cold and laborious work that lasted for hours. Richard Livesey helped Bernie, along with Engineman First Class Melvin F. Gouthro, the station's senior engineer, and one other unnamed individual.

As Bernie's crew left to tend to fishing boats, a call to the watch room came in that a 503-foot oil tanker, the *Fort Mercer*, had broken in two about twenty-seven miles east of *Pollock Rip* Lightship.

When Bosun Cluff ordered Bernie out to tow fishing boats, he also ordered Chief Donald Bangs to Stage Harbor at Chatham's western edge to another motor lifeboat, the *CG36383*, to assist the *Fort Mercer*'s crew. The *Fort Mercer* was a T2 SE A1, known colloquially as simply T2. The *Fort Mercer* had left Norco, Louisiana, on February 12, bound for Portland, Maine, with eight of her nine tanks loaded with kerosene

and heating oil. For his crew, Chief Bangs chose Engineman First Class Emory H. Haynes, Boatswain Mate Third Class (Provisional) Antonio F. Ballerini and Seaman Richard J. Ciccone. Bernie wrote in his memoirs "As these men left the station, I felt as if I was watching them go off to certain death."

It was not until Bernie, Melvin and Richard returned to Station Chatham in the middle of the afternoon, long after the *Fort Mercer* rescue was underway, that Bosun Cluff had more news for them. Unbelievably, another oil tanker with nearly identical specifications as the *Fort Mercer*,

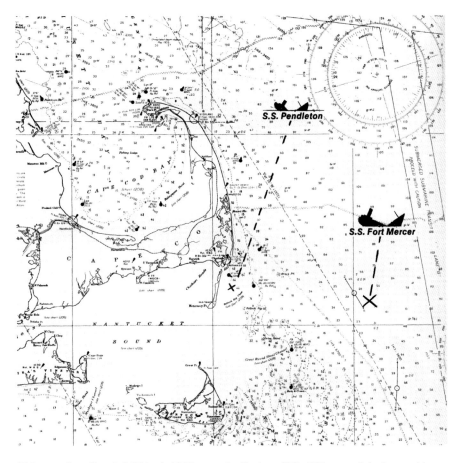

This map from Bernie Webber's 1985 memoir, *Chatham: "The Lifeboatmen,"* depicts positions of the SS *Fort Mercer* and SS *Pendleton*.

the *Pendleton*, had also broken in two and, as Bernie remembered, "was expected to move in close somewhere along North Beach between Orleans and Chatham."

Daniel Cluff had ordered Bernie to take the station's Dodge Power wagon, drive to Orleans and try to look for the *Pendleton*. "Once there we were to meet up with Roy Piggott and the Nauset Lifeboat Station crew in the amphibious vehicle DUKW." The DUKW is a World War II–era amphibious truck with six-wheel-drive capability designed by General Motors to transport goods and troops over water and land, and the vehicles maneuver well on sand. Cluff reported into Boston, and Boston made a report to an aircraft, PBY 1242, stationed in Salem. Presumably they had seen the bow of the *Pendleton*.

"Together, we were to proceed out to Nauset Beach and attempt to locate the stricken vessel and render aid should it come ashore," Bernie explained.

Bernie's first thought was for his friend Donald Bangs, already several hours out of Stage Harbor and engaged in the *Fort Mercer* rescue, and "how cold and miserable they must be by now."

The snow, ice and wind made driving to Orleans hazardous. Bernie remembered, "The four-wheeled vehicle plowed on through." They met up with Piggott and his crew, and together the Coast Guardsmen set out for Nauset Beach. A hill near Mayo's Duck Farm afforded a view of the shoreline.

"A brief clearing in weather showed a ship, rather a half of a ship, black and sinister, galloping up and down along huge waves, frothing each time it rose and settled back into the sea." This could be only one ship: the *Pendleton*. The only way to get word back to Bosun Cluff at Station Chatham was to drive there, so Bernie, Melvin and Richard hightailed it to the watch room in that Dodge Power wagon, with Piggott and his men following in the DUKW.

In the meantime, Chief Bangs and his crew found no living soul on the bow section of the *Fort Mercer*. According to Bernie, the pressure was on for Cluff, who had arrived in Chatham only several months before and busied himself only with station renovations over boats and rescue procedures. Added to that dynamic was that men who should have been in on decisions that day were unavailable or off-Cape. Alfred Volton

could not get to Chatham because of the weather, and the regular group commander, Everett Marshall, was on leave.

"Cluff was from Virginia," Bernie explained. "A very Southern, nice man, but totally inexperienced and had absolutely no knowledge of Chatham." Now a decision needed to be made, and fast, but the man responsible for deciding "hardly knew what our boats looked like, or where Chatham Bar was…had never been out on the water," Bernie added.

In his Southern drawl, Cluff told Bernie to "'pick yourself a crew. Y'all got to take the *36500* over the bar and assist that thar ship, ya hear?'" as Bernie remembered the conversation. Some have said the regular station crew took cover when Webber, on orders from Cluff, began to field his rescue team. And that's still a sore point with a lot of folks today.

At any rate, this order followed two earlier ones by Cluff: to tow adrift fishing boats and locate the *Pendleton* from land. As Bernie would learn, his day was far from over.

Bernie looked around for three colleagues to start a mission he believed would kill them. Ervin Maske was in plain view while patiently awaiting transport to *Stonehorse* Lightship and passed time in the mess hall. "Lots of times I used to cook for them. Anything they wanted: baked dishes and pies, homemade bread…I had 'em spoiled when I was there," Ervin would say fifty years later in a quiet moment at the May 2002 reunion in Boston in the parlor of Mariners' House in Boston's North End. Ervin volunteered for Bernie's mission. He was just that kind of guy. "He didn't have to, he could have just looked at me and walked away, because he wasn't part of the regular Chatham crew," Bernie remembered. "Bosun Cluff ordered us out, and we went out."

Andy Fitzgerald, from Whitinsville, Massachusetts, joined the rescue team as engineer. "I doubt that I would have been considered for the *Pendleton* rescue, except we were short handed and for the fact that EN1 Melvin Gouthro became sick upon returning from Orleans, and because of other rescue attempts that day," Fitzgerald remembered in an e-mail exchange with co-author Webster. "One of the other enginemen was sick and the last one was on leave. Fate is funny sometimes." Enginemen were prized commodities at Chatham. "The station engineer's main duty was to row out to the three boats we had, start them up and check such things

as fuel level, battery, etc…, to make sure that they would run if needed," explained Andy in a recent e-mail to the authors.

Richard Livesey rounded out the crew. "We'd already been out the whole day, we knew how rough it was going to be out there, to tell you the truth, ya know, looking out at North Beach, you could see huge waves breaking on the beach," Richard remembered.

"Ervin was not assigned to Chatham, so I didn't know him very well at all," Andy remembered. "I did know Richard quite well. He seemed to be a happy-go-lucky guy with a good sense of humor," Fitzgerald added about Livesey. "I think our relationship was the same before and after the rescue."

Keeping warm was on the men's minds: "We had what they call 'foul weather gear,'" Richard said, "I don't remember what it was made of." The material—the woolens, cottons and oilskins, which were state-of-the-art in 1952—was no match to today's foul weather garments used by the Coast Guard.

Bernie, twenty-four, had been in the Coast Guard six years, the longest compared to Richard, Ervin and Andy, all of whom were in their early twenties. He had seen enough death, experienced as a boatman above the shifting shoals on the Chatham bar, to know they were in serious danger. "It was logical for me to be the one to make this attempt. After all I knew the waters and the territory better than anyone else at the station," said Bernie. What Bernie did not know was the iron faith Andy Fitzgerald had in his coxswain. "I don't think anyone at the station could get over the bar better than Bernie."

Within minutes, Richard Livesey, Ervin Maske, Andy Fitzgerald and Coxswain Bernie Webber left the pier and maneuvered themselves into a dory and rowed to where the CG36500, a thirty-six-foot motor lifeboat, was moored. It took only a few minutes to get underway: unfasten lines to the anchor; fire up the ninety horse power gasoline diesel engine; and check the throttle. Daylight had slid into night.

"As we sailed down the harbor it was dark," Bernie clarified fifty years later. By then, Bernie, Andy, Ervin and Richard were "freezing cold and soaking wet," and the mission was only in its infancy, with the blanket of black and winter spread over them snugly. "I've been in and out over that

bar hundreds of times but never in anything like this," explained Webber decades later.

Nearing the bar, the crew radioed the watch room several times to confirm orders. For an instant their hopes were raised higher than the waves surrounding their lifeboat. "This is where they're gonna tell us to turn around!" Webber shouted to his crew. Instead, a panicked and inexperienced Bosun Cluff said "Proceed as directed, those are your orders." A fear as tight as their life jackets wrapped the four and wouldn't let go, and the blanket of black and winter was pulled in even closer.

Onward they went, past the red blinking light of the buoy that marked the entrance to Old Harbor, the last shred of technology wedged into the waves. Approaching the notorious and dynamic Chatham Bar, the crew began to sing *Rock of Ages*, a favorite of Ervin's, and *Harbor Lights*. The storm muffled their voices. At that moment, Richard, Ervin, Andy and Bernie were truly on their own, afloat atop the cruelest of elements: a nor'easter, bobbing and weaving into seas that could overwhelm the *CG36500* in an instant. Only Bernie's boatman skills and their collective brawn kept them alive.

At that moment aboard the *Pendleton*, about five miles outside of Chatham, it was chaotic, remembered Charles Bridges, eighteen, the youngest seaman aboard. Earlier, when he was fast asleep, the T2 tanker split in two early on February 18, and Bridges awoke to grinding noises and odd vibrations and, like the rest of his shipmates, was clueless that the *Pendleton* lay in two pieces. "We had no idea the ship had broken into two," he would later say.

Bridges grabbed his pants, his lifejacket and shoes and "went topside till morning," he remembered. "You couldn't see anything," said Charles, but he knew enough to tell the other guys "The other half of the ship is gone." His feet slid on the icy decks. "One guy was still asleep at 8 in the morning," Charles recounted.

Charles was the sailor who went room-to-room, rousing and warning with, "Hey, you better get up. The ship's broken in two."

Bridges was in the stern section when Engineer Ray Sybert saw the stern headed for grounding on Chatham's bar and certain disaster. He used the tanker's engines to keep the vessel off the bar, but this only

increased the vessel's list and trim dangerously. When Sybert's crew learned from their personal radios that a motor lifeboat from Chatham was on the way, Sybert quit trying to maneuver the stern.

Throughout the day on February 18, the *Pendleton* crew lived minute to minute, not knowing whether the stern section would go belly up one last time and sink, drowning the surviving crew. They could not send an SOS; the radio room near the bridge had been destroyed. All they could do was wait.

Chapter 3

THE *FORT MERCER* RESCUE

The *Fort Mercer* began to snap apart at around 8:00 a.m. on February 18—after the *Pendleton* had explosively cracked in two. Fortunately the *Fort Mercer* sent a radio distress signal SOS and kept the Coast Guard at Chatham and Boston appraised of their deteriorating situation for nearly four hours until the bow finally separated from the stern shortly after the tanker's change of watch at noon. The Coast Guard's early efforts on February 18 were focused on rescuing seamen from the two halves of *Fort Mercer* some twenty miles off Cape Cod.

By midmorning on February 18, the men at the Chatham Lifeboat Station (today known as Coast Guard Station Chatham) received word about the *Fort Mercer*'s predicament. Orders were received for the station to launch a motorized lifeboat to assist the *Fort Mercer*. Officer in Charge Daniel Cluff dispatched Boatswain's Mate Chief Donald Bangs and his crew in the *CG36383* to assist the *Fort Mercer*.

A veritable fleet of larger Coast Guard cutters were responding to the *Fort Mercer*'s S.O.S. location, some having transited from a search area off Nantucket, where two fishing vessels were thought to have sunk. Only the quarter board from the fishing vessel *Paolina*, later presumed to have sunk, was recovered in that effort.

The stern of the stricken SS *Fort Mercer. Courtesy of the U.S. Coast Guard and Bernard C. Webber.*

The Coast Guard responded with all manner of resources. Before the *Fort Mercer* rescue efforts were concluded, the cutters *Eastwind, Unimak, Yakutat, Acushnet, McCulloch,* two thirty-six-foot motor lifeboats, numerous aircraft and additional Coast Guard craft and personnel would answer the call. The navy ship *Short Splice* was first on scene with the *Fort Mercer's* crew left on the stern section and offered the comfort and knowledge that Coast Guard rescue ships were close at hand. The icebreaker *Eastwind* with the senior Coast Guard officer onboard was the first rescue-equipped craft to arrive on scene and fired a line that later carried portable radios for communications between the vessels. Cutters *Unimak* and *Acushnet* soon arrived on scene.

The icebreaker and the *Fort Mercer's* stern were still connected by a line. It was used to convey a rubber boat near the broken tanker. The first crewman jumped into the frigid waters and made the cold wet trip

to the *Eastwind* with a muster list of *Fort Mercer* crewmen who were left on the stern. Two more survivors braved the treacherous trip between the vessels in the rubber boat and scampered up the *Eastwind*'s cargo nets.

Ensign Stabile, observing from the cutter *Unimak*, noted: "The ship (*Eastwind*), being an icebreaker, rolled very heavily so the men were getting the Coney Island cyclone ride with part of the cycle under water before shooting sixty feet into the air hanging on for dear life. The rest of the men on the stern section watching that decided to take their chances on remaining aboard."

The skipper of the *Acushnet* then petitioned the captain of the *Eastwind* and suggested he could more effectively remove crewmen from the stern of the *Fort Mercer*—using just the *Acushnet*. From the December 27, 1952 issue of *Collier's*:

> The *Acushnet* *had been ordered to sea at Noon the day before. At the time she had been laid up, with her engines partially dismantled and her crew scattered throughout the snowbound city of Portland. Yet three hours later she was on her way, with every man of the crew aboard…* *Joseph (Lieutenant Commander John M. Joseph) let the* Acushnet *drift towards the* Fort Mercer. *Then turning his bow out and easing his stern quarter toward the larger vessel, he closed the gap. The trick was to get near enough for a man to jump across and still keep the two wildly rolling, pitching ships from grinding together. The* Acushnet *got five men on her first pass; then the sea knocked her out of position. Joseph signaled full speed ahead and circled around again. "…This time I really had it," he remembers with satisfaction. "My ship came right in on* Fort Mercer*'s stern section and I held her there while we took off thirteen more. We could have taken everyone aboard on that pass but no one else wanted to leave."*

Thirteen men would remain on the stern section of the *Fort Mercer* when it was later taken in tow the day following *Eastwind* and *Acushnet*'s heroic rescues. They all were later safely evacuated.

The navy ship *Short Splice* was again the first entity to make contact; this time with the *Fort Mercer*'s bow section, which had drifted away from the

stern section and did so in the early evening hours of February 18, well after dark. *Short Splice* again brought with them the welcoming news that Coast Guard ships and potential rescue were just a few hours away. The navy ship and the senior *Fort Mercer* crew, now cloistered on the stricken vessel's bridge, communicated via blinking light and Morse code.

Shortly before 8:00 p.m., cutter *Yakutat* arrived on scene and commenced to attempt to connect the two vessels using shot lines. The first seven shots missed their mark in strong winds, but the eighth shot of line landed high in *Fort Mercer*'s rigging, unretrievable.

A new rescue plan was quickly devised. *Yakutat*'s crew would cobble together all manner of line, lights and rubber rafts. *Yakutat* would then trail the parade of connected rafts aft and close enough to the bow of the *Fort Mercer* in order for the stranded crew to jump near the rafts and then haul themselves onto the makeshift daisy chain of the rescue craft.

Even before this was possible, however, *Fort Mercer*'s senior crew members had to navigate the treacherous landscape of the broken ship from the bridge across a labyrinth of twisted steel to the steeply inclined bow area. A makeshift climbing rope was fashioned from the hoisting line used for signal flags. If the men were to be rescued by the *Yakutat*, the bridge-bound *Fort Mercer* crew had to exit a porthole and shimmy down onto an inclined catwalk, timing their decent to the huge waves that licked their heels and then creep forward on unsteady and slick surfaces to the relative safety of the bow.

One crewman would quickly perish and be swallowed up by seas as he attempted to transit from the bridge to bow. Four others were finally positioned on the bow even before all the remaining crew had made their way to the bow area. Just then, the line connecting the rafts to the *Yakutat* catastrophically parted. Unfortunately, and with tragic consequences, three of the four *Fort Mercer* crew on the bow saw the fast-approaching procession of rafts as their only chance for salvation and jumped to their deaths in the churning winter seas. The *Fort Mercer*'s captain and three others arrived soon thereafter and found just one extremely lucky crewman remaining on the bow.

Yakutat would spend the next two hours chasing down the runaway rafts and finally retrieve them for another try. *Yakutat* then returned close aboard the *Fort Mercer*'s bow to make sure the hulk was still afloat before allowing *Yakutat*'s exhausted crew a few hours rest before the new day's next rescue attempt. One of *Fort Mercer*'s crew, however, misinterpreted the *Yakutat*'s close approach as a rescue and leapt overboard and perished making the attempt to bridge the gap between the two vessels.

The four remaining *Fort Mercer* crew, including the ship's shoeless captain, would spend the next several hours warming themselves as best they could and only hope that the new day would bring a renewed effort to save them. Their strength was slowly ebbing, draining drip by drip from their bodies like a lawn spigot, due from exposure with every passing hour. *Yakutat*'s captain devised a plan involving the daring use of a Monomoy motor surfboat, driven by Ensign William "Moose" Kiely. Kiely was assisted by Ensign Gilbert Carmichael, Engineman Second Class Paul Black, Seaman Apprentice Edward Mason and Seaman Webster Terwilliger, all volunteer crewmembers. Kiely's medal citation later read in part:

> *The motor surfboat, which was damaged by heavy seas while getting away from* Yakutat, *was skillfully maneuvered to the unstable bow section of the* Fort Mercer, *and the survivors encouraged to jump into the water, close to the boat, so that they could be picked up. On the first pass, the surfboat was lifted and swept against the hull of the* Fort Mercer. *However, two survivors leaped into the water and were recovered by the skillful seamanship and daring of Kiely and his crew. The motor surfboat was now severely damaged and in a sinking condition, and it was necessary to return to the* Yakutat.

Although Kiely was determined and confident he could make the return trip to the *Fort Mercer* in another boat, *Yakutat*'s skipper knew the odds were not in favor of a repeat successful performance. A new plan using rubber rafts would retrieve the two remaining *Fort Mercer* crewmen. The bow section of the broken tanker was now perilously close to sinking, having taken on a sixty-degree list.

Upon approach, *Yakutat*'s first shot of line found its mark on the bow of the *Fort Mercer*. The line was secured and the two remaining crewmen retrieved the raft by hauling in on the *Yakutat*'s line. When the raft was close enough, the line was then tied off to the *Fort Mercer*'s bow section. The line connecting the raft to the bow hulk would be untied or cut by the *Fort Mercer* survivors once the two crewmen were safely aboard the raft.

The first *Fort Mercer* crewman jumped and safely made it to the raft. But, the raft had overturned. It took every bit of this crewman's strength to right the raft, but after this Herculean effort, he hung limply from the craft's side, immersed in the numbing cold North Atlantic waters. The final crewman knew what he had to do to survive.

Jumping from the bow, he made his way to the raft and hoisted himself onboard. He then assisted his shipmate aboard. Now, there was only one problem. Both survivors were so incapacitated by the cold; neither could open the knife to cut the line that connected the raft to the bow of the *Fort Mercer*. They could see what needed to be done to save their lives, but, agonizingly, they couldn't muster the strength for the task. It was up to *Yakutat*'s captain to take swift action in this latest crisis.

Yakutat's engines were ordered slow astern with the hopes that when the line parted, the rubber raft with two *Fort Mercer* crew aboard would stay with *Yakutat*. In the worst case, the raft would remain with the bow of the *Fort Mercer* and certainly be pulled under when the bow finally sank. Inaction would mean certain death for the two survivors as the bow was perilously close to capsizing. The fortunes of fate were with the two men and as the line parted from the strain of *Yakutat*'s efforts, the men and the raft remained attached to the *Yakutat*. *Yakutat* soon retrieved the last two *Fort Mercer* crewmen.

Yakutat's Ensign Kiely would be the only Coast Guardsman to receive the coveted Gold Lifesaving Medal for the *Fort Mercer* rescues. His four other Monomoy boat crewmen would receive the service's next highest award for bravery, the Silver Lifesaving Medal.

All told, thirty-eight of a total of forty-three *Fort Mercer* crewmen were either rescued or survived their ordeal. Thirteen remained safely aboard the stern section. Twenty-one were evacuated by *Eastwind* and *Acushnet*. And, four were rescued by *Yakutat*.

Chapter 4

ABOARD THE CG*36500*

"The first sea over the bar hit us, picked us up, turned us around and threw us back into the harbor," Bernie recounted, as cleanly as if the memory was fresh as rain. "Breaking seas over the lifeboat in through the windshield opening along with the violent motion of the boat tore the compass from its mount," remembered Bernie. To add to their worries, "the windshield was smashed in, shattering into a million pieces," Bernie added.

Crossing the bar sent shallow but thick waves smashing against the motor lifeboat, throwing the vessel high in the air to land on its side in the valley between two waves. The boat was designed to self-right, thanks to a hull of two thousand pounds of steel, and was quickly smote. Topside, a wave smashed the windshield, sending glass into the seas and ripping the compass from its mount. Webber struggled to regain control of the CG*36500* and steer into the waves. Finally, the waves had increased—and so had their height—and Bernie knew by this time he had crossed the bar. It was one small success at a time in a night where death peered around every wave.

Weather observations from nearby cutters involved in the *Fort Mercer* and *Pendleton* rescues indicated sea heights between forty and sixty feet. Bernie kept going and motored into the biting night into the lap of the nor'easter. "There are people who can discuss these things and argue

them six ways to Sunday," he added. "Most of them who put up the greatest questions are those who never went to sea. It's hard to imagine certain things and this is one of them."

"When we first headed out of the harbor, Bernie asked me to man the search light in the forward compartment," Andy explained. "When we hit the first big waves starting over the bar I was lifted off my feet, as the others probably were, too. I don't remember anyone being swept out of the boat, but we were all very busy trying to keep on our feet and it could have happened without me seeing it." Fortunately, all the CG*36500* crewmembers remained on the vessel.

There was "so much foam," Livesey recalled fifty years later. "The Lord above was looking down on us, and finally got out there after water broke on us and the windshield busted." The seas were "really big," he added, and the crew had doubts they were going to make it. "I don't know how the other three hung on, I really don't, because I was strapped in," Bernie remembered, using his hands to motion how the strap held him to the wheel.

It would "go around your waist and hook in on the other side so I'm like this, you know," he said, reenacting the posture. "Four guys back aft in that little cockpit all trying to stand in that coxswain flat and hang on to the rail there, I mean that's crowded, I don't know how they did it, because of the way we were being thrown around," said Webber. Back on the CG*36500*, Bernie and his crew were slowly freezing to death. The frigid wind, the winter cold, seeped through the thin layers of their gear and reached into their skin. There were small blessings, though; had the seas claimed Richard, Andy or Ervin, who were wearing life jackets, Bernie thinks, "They would have at least found them dead, frozen, but floating."

Bernie, however, was unable to wear a life jacket. "It would have been too confining," he remembered. "After we got over the bar the boat rocked and rolled, but it wasn't violent enough to lift us off the deck, and I thought we'd be OK if it didn't get worse," clarified Andy. It did get worse with waves relentless in their attack on the CG*36500*. No one said much as the hunt for the *Pendleton* began.

Aboard the *Pendleton,* with each hour that passed without rescue, calm despair rippled through the ranks with only the hope of rescue keeping

spirits up. The *Pendleton*'s engineer and his crew sensed imminent death each time the stern hulk hobby-horsed southward, smashing bottom with each new series of waves. Seasickness crawled through the rank and file. Although several Coast Guard cutters and the CG*36383* were nearby, only the CG*36500* was in any sort of position to try to save Engineer Sybert's men.

"I'd tell them to 'watch out for this,' or, 'hang on!' Sometimes you'd go up on a sea, and I knew by the time we'd get to the top of it, we were gonna go somewhere when we'd get to the other side of it," Bernie recalled. "Then the next sea would hit you and pick you up in the air." Some parts of Chatham Harbor and Nantucket Sound are shallow, and Bernie said when "you hit bottom, you come down off a sea and boom to the bottom and there you'd stop." For Bernie, who first recounted that night in eerie detail in 2002, the passage of fifty years did not dim his memory of the mission.

It seems unimaginable, but in truth, the walls of seas towered on either side of the CG*36500*. Talk of sixty-foot-high waves has become part of the tapestry of the *Pendleton* story. Over fifty years later, Bernie would say, "I've never made any claim about anything. There were enough other people talking, in fact. Nobody ever asked me," he clarified. "Listen, the only way I know," Webber added, "I mean, I know how bad it was, where they get this forty feet, sixty feet, are from ships that were offshore. They have instruments that measure these things. And there were many different ships out there from different agencies. A navy vessel out there, three or four Coast Guard vessels out there, a couple of merchant ships out there, and all of them, with their sophisticated equipment were making weather and sea condition reports," Bernie explained. "I know that sounds high," he offered, when asked about the sixty-foot-high waves, but "I've seen them in the North Atlantic one hundred feet high."

The CG*36500* lumbered like a roller coaster at the county fair, laboring up one side of a huge wave then surfing without a care down the backside, accelerating towards the trough. Coxswain Webber knew too much speed was unwise and unchecked; the boat's bow could easily be buried in the next wave and the small vessel would be swamped. The boat's motion was so swift Bernie reversed the engine on the backside of

each wave to slow the *CG36500*. Webber's first navigational waypoint was the nearby *Pollock Rip* Lightship where Bernie had hoped to reorient himself and give his crew a breather in the lee of the larger vessel. But the weather worsened, and so did the visibility and the freezing horizontal snow tore at Bernie's raw face through the broken windshield.

But Coxswain Webber—under Bosun Cluff's orders—drove the *CG36500* deeper into the nor'easter, looking for a ship that he feared his crew, all of whom were just a few years out of high school, would never find. "It seemed like forever, but actually I made very good time."

Every so often the lifeboat's engine would konk out when waves rolled the *CG36500* over and the ninety horse power gasoline diesel engine lost its prime. When that happened, Engineer Fitzgerald crawled into the cramped compartment and restarted the engine. His efforts were rewarded with severe burns and bruises, and gratefully, the steady chug-chugging of the engine and the collective sighs of appreciation from his shipmates.

When asked how he located the *Pendleton*, however, Bernie simply says, "Don't know. First I knew of it, I heard it, this rumbling, crashing, banging sound over the wind and the sea. And I sensed 'Geez, there's something there.'" If the seas and wind knocked out the compass and windshield, intact was the small searchlight which proved a godsend.

Then it happened. A wall of blackness actually deeper than the night appeared ahead before the *CG36500*. Bernie sensed something was there. Years later, the memory of that eerie sensation would send chills through his body. "I had a crewman go forward and turn on the searchlight," Bernie recounted. "Also, one could hear a hissing sound," from the *Pendleton*, Bernie said, "almost like a screeching, hissing sound. I think it was every time it went down into the sea with all the metal hanging off it, it created this noise. Very hard to explain, but I just knew something was there."

The searchlight combed ahead and nailed its mark: the *Pendleton* was dead ahead, a black mass of twisted metal heaving high into the air atop massive seas, settling back with a thud into "frothing mass of foam." Divine intervention, dead reckoning and plain luck have all been trumpeted as ways Bernie's crew found the *Pendleton* that night. "I was

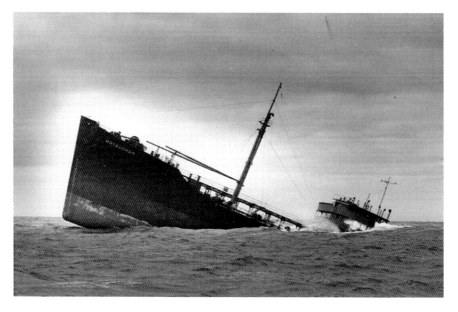

The bow of the hulk of the SS *Pendleton. Courtesy of the U.S. Coast Guard and Bernard C. Webber.*

looking right into where it was broken in half. Just a white crawling mess and it would just rear up high in the water, and then settle back down with a crashing and a banging. I don't know how otherwise I'd found it, I just heard it."

Bernie credits chance for the find. "Luck, cuz I was trying to find *Pollock Rip* lightship…so I'd know where I was, and know I was off-shore in deep enough water, and then take it from there. Nobody knew where the *Pendleton* was." Not even the Chatham Lifeboat Station. "Chatham Radar didn't know where the *Pendleton* was. If Chatham Radar knew where the *Pendleton* was and knew where we were, they could have helped us find it. But they never helped us," Bernie continued. "I had nothing really to say, and they didn't say anything to me, I could have talked to them, but we were just making our way along, hanging on."

In Bernie's words:

> *I went down to the port side* [the left side] *and there were no lights on and the railings up there were kind of bent and smashed and I could see signs of damage, and I says, "Geez, maybe no one's on board, there's no*

lights on or anything." As I found the stern, and I made out the name
Pendleton, *Wilmington, Delaware, so I knew for sure now what I'd
found. Went around to the starboard side and by God there were lights
on, deck lights shining a little yellow glow up there.*

"The wreck was impressive and scary looking but I never thought we
would be swallowed by it," Andy remembered, adding, "I'm sure I would
have been petrified if I thought that was going to happen."

The fresh hulk towered over the small CG*36500*, said Andy: "I
wondered how we would get anyone off if they were still alive."

"I saw one man, he looked about the size of an ant, standing at the
rail," Bernie remembered. "My first reaction was 'Holy shit, we came all
this way for one guy! Four of us, we came for one guy!'"

"I'm thinking to myself, 'How am I gonna get him off? He's gonna
have to jump, it's high up in the air, say thirty feet. And when the ship
would rise, it would be more,'" Bernie remembered.

Andy would always think the CG*36500* crew was lucky the *Pendleton*
carried a very long Jacob's ladder and one that survived the initial
breakup of the vessel. "I did crawl up to the cockpit as we approached
the *Pendleton* in case lines were going to be thrown to us," said Andy. "It
was soon apparent that this would not work. We were bobbing up and
down so much any lines would have immediately snapped."

Webber's crew did not have to think on that question too long. "Well,
a few seconds later they started coming out from inside the cabin there,
they all came out and lined the rail, they threw over a Jacob's ladder. And
I looked at it and I'm thinking to myself, 'Maybe we ought to get off this
lifeboat and get on that ladder and climb up,' but before I could think
much more about it, they started coming down, they wanted off," Bernie
recounted. "I saw them drop a ladder over the side and they started
down. I then crawled back to the other compartment to see if I could
help grab them as they jumped," added Andy.

What would be a historic rescue mission—the greatest small boat rescue
in Coast Guard history—had begun. The first man at the bottom dropped
in the water like a fishing lure, and was lifted fifty feet when the *Pendleton*
rolled and heaved. Webber called on his crew to assist the first survivor.

"Richard and Ervin came to the compartment to help them, too." The rescue mission—though the actual evacuation of humans from the mortally wounded T2 tanker—had begun, the danger was far from over. Bernie described the situation:

> *I had to make several passes. Those guys at the bottom of the ladder, there had to be two or three others somewhere on that ladder. Well, you could only get one guy at a time off that ladder, and I'd have to judge and see. If I got in there at the wrong time, I could come up underneath him, with the lifeboat and hurt him badly. On the other hand, if I came in on the back of the sea, I could run right into him as the ship rolled and he went down and I come in off the sea I could hit him. So I had to be careful to try to get the lifeboat in there, get it near him, and wait for the right moment and put it ahead so he could jump...we'd be close enough for him to jump, and just hope that the guys grabbed him, which mostly they did. Sometimes I'd make three or four passes for one guy.*

Coordination was critical, and over time, Bernie's many trips on the CG*36500* made the driving of the vessel "second nature to him." Webber and the *36500* operated as one machine now. Each *Pendleton* crewman required at least one pass, and sometimes Bernie had to make several to get one man aboard. "Just to maneuver up alongside, it required constant work with your left hand steering, with your right hand throttling in and out of gear back and forth," he remembered. "I mean, it was work, it took a lot of effort."

With finite skill, remarkable for a boatman so young, Bernie maneuvered the CG*36500* along the *Pendleton*'s starboard quarter, and one by one, the merchant mariners either jumped and crashed hard on the tiny boat's bow, or fell into the freezing, churning water where Andy, Ervin and Richard plucked them aboard at great personal risk to themselves.

The seas rolled the CG*36500* to and fro but kind fate held as the *Pendleton* crew, one by one, made ready for their rescue. "I remember the guys started jumping into the water, and as they were jumping into the water we'd get a hold of them, pull them aboard the boat," remembered Livesey. "I can remember doing that, time and time again."

"First you only saw one, then ya seen a whole bunch of 'em there, then ya start loading 'em on," Ervin remembered in his quintessential Midwestern twang. "As they came aboard we literally stuffed them into the covered forward compartment. After a while, they overflowed out of the covered portion and were all around us. When the compartment filled up they went to the stern area around Bernie and some went into the engine compartment," Andy clarified. Bernie remained strapped to the wheel, and Andy, Richard and Ervin struggled to get the soaking, cold merchantmen aboard the CG*36500*.

"If you hadn't been there, half of those guys wouldn't be here," Bernie would say to Andy half a century later over a breakfast of toast and eggs with Fitzgerald in Chatham in May 2002. "I know that for a fact, because I was in a perfect position to look at what was going on, and Ervin worked like heck, but somebody had to set the pace and lead the troops, and that's the guy who did it," and having said that, Bernie pointed a finger right at Andy. "Somebody had to have the strength and know what to do and when to do it. A lot of guys would be hanging on themselves, afraid they'd be going overboard." Some *Pendleton* crewmen were 'slingshotted' out from the ship on the Jacob's ladder by the whipping and rolling motion of the waves. As soon as they had reached their zenith of flight, the ship would snap roll them back, violently, slamming them against the side of the 503-foot tanker.

Steering and maneuvering the CG*36500* for each pass off the *Pendleton*'s stern was arduous. A coxswain "needed three hands to operate it," Bernie explained. "One hand to steer, my left hand, and with your right hand there was a lever that you pushed forward to put in gear, and pulled back to go into reverse, all the while operating the throttle." Bernie had to keep the "throttle separate from that which controlled the speed of the engine. So you pushed the lever ahead, move the boat ahead, and rev up the engine, when backing down, throttle the engine down before pulling the level out of gear so you wouldn't strip the transmission out of the boat."

"We couldn't even hear each other," Bernie recalled, and Ervin, Andy and Richard used hand signals to communicate with one another. "They knew when I started easing up to a man on the ladder, timing it right, they stood by prepared to pick the guy up if he landed on decks or in the

water." The merchantmen on the *Pendleton* cooperated fully and since they worked the high seas there was little panic on their part.

Charles Bridges, a crewman aboard the *Pendleton*, and the sole tanker crewman at the 2002 reunion, remembered the CG*36500* would "come in and somebody would drop off, then the wave would take it out, and it would come in again."

Bridges does not remember anyone being scared and "I guess we all had the same feeling: whatever is going to happen, is going to happen." Though small, the CG*36500* was perfect for this rescue. "It had to be a small lifeboat, because no other large ship could get near the *Pendleton*," Bernie insisted. "All I can remember is some of them hit the forward deck, it's curved, it's a turtle back, and my crew grabbed hold of them," Bernie said, adding "those who fell into the sea were grabbed by my crew." He likened the motion to a fisherman "slinging a bunch of tuna fish aboard."

The workspace was tight and, one by one, the *Pendleton* men were crammed in everywhere and anywhere on the CG*36500*, which carried a maximum safety rating for fifteen including the crew. "Shove 'em in the forward compartment, shoving them down in the engine room, and once that got full, filled them in behind me in the canvas strongback," Ervin said. The survivors' compartment was not an easy entry. The door size was small, about two and a half feet, with a height not around three feet.

After multiple approaches to the foundering *Pendleton,* twenty survivors were aboard, alive, at least much into the mission. And they knew they were long from safety. To worsen the mission, the CG*36500* began to handle sluggishly.

For Bernie, this is the moment he decided that all aboard would either live, or all aboard would die, but whatever happened, they would do it together.

Thirty-three crewmen were aboard the *Pendleton* when the CG*36500* first pulled up alongside the stern and the Jacob's ladder was flung over the side. Thirteen merchant seamen were still aboard the *Pendleton.* And the human parade continued.

No matter how hard they tried, Bernie, Richard, Ervin and Andy couldn't save *Pendleton* crewman George "Tiny" Myers, and the memory

of his death would haunt all four *36500* crewmen fifty years later. "We killed a guy so that took an awful lot" out of the crew, Bernie said, pausing, and then uttering, "I remember everything" in a tone that suggested he wished he had forgotten everything but never would.

"I'd seen death before; I'd seen a lot of people killed on the bar in Chatham and in other incidents and so forth, but nothing that stood out quite like that," Bernie remembered. At over three hundred pounds, George "Tiny" Myers belied his nickname. Myers, a common seaman, lumbered down the Jacob's ladder. "He was as far as the crew and as far as the records go, the last one down," Bernie reflected, but in reality, Myers disembarked the *Pendleton* about midway through the rescue mission.

When Tiny Myers began climbing down the Jacob's ladder and Bernie caught sight of him, a married man with a young son. "What a strange sight in the middle of a Northeast storm out to sea in a ship that's broke in half, and here comes a fella, very heavy, with barely anything on."

George Myers also wore no life jacket. Bernie said he could not "understand that to save my soul." Myers "hit the boat and slid off into the water," and as Bernie relayed the memory, Tiny Myers was dying yet again in Webber's mind. "I think Andy said he had a hold of him, but somehow or other, Tiny let go." "The fella that died" has never left Andy. "I see him lots of times in the water," Fitzgerald recalled fifty years later. "We couldn't help him and he couldn't help himself," added Bernie.

Richard and Ervin rushed to help Andy with Tiny, before Myers finally let go. "It looked to me like he'd just fallen into the water off the ladder coming from the ship, and we reached down to grab him, all the other guys seemed like we could get 'em, pull them up quick, but Tiny we couldn't," remembered Richard. "I had a hold on him but I couldn't hold on to him," Ervin said.

"I see his eyes looking right at me," Bernie recounted. "I could look at you and I could see his eyes, and actually the message I was getting was 'It's OK.' Somehow or other I got that."

"I'm looking at him there, and I'm trying to get in there to get him. The hull of that ship curved right down to where the propeller and the rudder were, and he was right down in there by that propeller," Bernie said. Then a wave pushed the *CG36500* into the *Pendleton*'s hull and crushed

Tiny, and Ervin's grip on Myers was gone. "Then he got crushed and my fingers were all black and blue the next day," Ervin remembered. "They were crushed right alongside cuz I had to hold him when it happened. Yeah, when you get hit like that across the chest—all he did was, 'uh,' he hit pretty hard and he must have crushed every bone in his body. My fingers got all black and blue the next day."

"The wave picked us up, and Tiny grabbed hold of a line on the boat, but the wave picked us up and threw us," recounted Richard. "The next time I looked, he was floating away."

The Coast Guardsmen were devastated by Tiny's sudden, horrific death.

A second portion to the Myers story, buried beneath the waves of 1952, is something about which Bernie had never before spoken publicly. Tiny Myers was not the last man to scamper down the Jacob's ladder from the *Pendleton*, unlike what everyone was led to believe for decades.

"SS *Pendleton* Chief Engineer Raymond L. Sybert and the *Pendleton* survivors concocted the story to place Myers in the best light for his family's sake," Bernie remembered. "For me, the fact was that after Fitzgerald let go of Myers and he was crushed by the lifeboat, I had a decision to make," he explained. "Continue spending time trying to get Myers's body or leave him and go pick up the remaining crewmen from the ship?"

Boatswain's Mate First Class Webber left Myers's remains to save the living. "My decision has haunted me all these years whether I did the right thing. Also, many could not understand how I lost Myers if he was the last man off, especially when I got all the others." Bernie and the CG*36500* crew were not involved in this humane deceptive plan, and for fifty-eight years the guys said nothing. "Bosun Cluff advised I not think about it. What was done was done," Bernie recounted. "It all just happened and I wasn't consulted."

Later Andy Fitzgerald would back up Bernie's story. "I never heard anything about Ray Sybert saying that Tiny was the last man off the ship. I was surprised to read that in one of the books. I know that there were people who came off the ship after Tiny's tragic accident and death."

Since Myers came down the ladder halfway through the mission, there were still twelve men aboard the *Pendleton* waiting for rescue.

"And that's why, from my perspective, after that happened, it was very difficult to go get the next guy, cuz the boat was already loaded, it might have been say, twenty men on there already, and very loaded, very heavy, not handling too well, and having gone through that, the next guy over there on the top, really feeling, 'Geez, do I dare go pick him off, because the same thing might happen again. And again. And again.' But, we did," Bernie recounted. "The thing is deciding how to go for broke, I mean, how are you gonna leave guys" aboard the *Pendleton*? Bernie wondered aloud fifty years later. "Thank God it wasn't fifty" men, he added. Bernie held true to his belief that all would live, or all would die.

After fifty-eight years, the story of Bernie Webber and the *CG36500* rescue of the *Pendleton* crew might be boiled down to a few sentences: "It was a case of survival," Bernie said, "not only for the survivors of the *Pendleton* but for us. There were no heroics." Nothing but the need to see daylight the next morning sustained the crew. "We all wanted to survive. I actually never thought we would," Bernie recalled. "The job is like a soldier. You go into battle; you don't think it's going to be a dance."

"Fitzgerald was in the engine room and Livesey was in that one compartment forward of the steering area," remembered Ervin. "I was in the back end with Webber by the radio." In a seemingly lucky stroke of providence, Bernie said "after I got the last guy off, all of a sudden that ship came down at us, just like this," he said, motioning with his hand, "and it dawned on me, 'that ship is gonna capsize and take us all,' then the *Pendleton* rose up, rolled hard to port and disappeared" without capsizing the Coast Guard vessel. The Coast Guardsmen had completed the key part of the rescue just in time. But getting back to port safely was the next concern.

Lost in zero visibility with no compass and thirty-six men aboard his overloaded *CG36500*, all of whom depended upon Bernie, Webber had yet another choice to make. Should he head east into the seas and hope to survive ten to twelve hours until a new day's light delivered a slim chance of transferring the rescued to a larger Coast Guard vessel? Or put the wind and seas on the small boat's stern and let them force the vessel ashore someplace where help might be nearby?

"There we were, alone, in the darkness," Bernie remembered thinking. "Where are we?"

Bernie assumed they were headed northwest. "What I did was to quarter the sea to get the easiest ride—if you go with the sea you've got these mountains rolling up behind you which can push you ahead and put you on the back of the sea and the next thing you're diving down into one you could bury the boat." Bernie steered at an angle because "if you go broadside to the sea then you've got them all crashing on your side, so you can just kind of ride along with them, and that's what I was doing."

"The boat was awfully heavy and low in the water, we had so much weight on board, the seas were following behind, rolling right over the top of us," recounted Richard. "You'd go up to the sea, you come up and you come down fairly quickly. The water was constantly swirling around us. From where I was standing, with merchant seamen all around me, I couldn't move, they couldn't move."

However, to Andy, there was hope. "I felt at that time the worst was over and we were heading back and we were gonna be OK." Bernie radioed Station Chatham to report in. "I had told them that I had thirty-two survivors from the tanker *Pendleton* on board and I was trying to make my way back in."

Once he briefed his superiors that he had thirty-two *Pendleton* survivors, a squabble between the nearby Coast Guard Cutter *McCulloch* and the Chatham Lifeboat Station ensued. One idea included off-loading survivors to the *McCulloch* at sea. "But before they could almost answer me, two or three of the Coast Guard cutters that were farther off shore—I don't know where they were—started giving me orders to bring the survivors out to them, and then there were arguments between them, and all kinds of conversations going on," Webber recounted.

Bernie was upset that "there was the questioning who had more say, seniority among the cutters offshore as to how and what decisions were being made." "Everyone can hear ya on the one channel you're on," said Ervin, who stood at Bernie's side when all this was going on.

"They wanted me to bring the survivors out to the larger ships—'Bring them out to us.' Well, my first question is: 'Where are you?' and if you know where you are, tell me where I am because I don't know where I

am." Webber added, "so the idea of bringing the survivors out to the larger Coast Guard cutter didn't make sense, especially because I had just gotten them off a ship that was bigger than most of the Coast Guard cutters, and I knew what it took to get them off, and I couldn't imagine what it would be like to try to put them on another ship out there in those conditions, so I disregarded what they had to say." Exhausted, freezing and now mad, Bernie remembered, "I hear all this crap going on, so I shut the radio off."

He remembered, "I shut off the radio so as not to be placed in the position of being directed to do what I knew was a bad decision on their part." [Later, Bosun Cluff would inform Webber that disciplinary action was a possibility along with a court-martial because "there were some ranking officers who didn't take kindly to the fact that I turned off my radio and made my own decisions as to what our actions and fate would be," clarified Webber.] "Just because we had success and landed all the survivors at Chatham safely didn't overlook the fact that I chose to ignore higher authority," he added. Cluff told Bernie not to worry about it. "I didn't know how much longer I could hang on," Bernie recalled. "I was just feeling so beat and worn, tired, wet and cold and so forth."

In another series of decisions Bernie shouted to his crew and the *Pendleton* survivors:

> *We'll probably hit the beach somewhere, I hope it's Monomoy, but if it isn't Monomoy and I miss it altogether we're going to wind up in Nantucket Sound and Good Lord we've got all the options in the world. If we have to go all the way to Nobska Point before we hit something, my attitude was "just find land." I'll hold it on the beach with the engine and get off as quick as you can. Don't ask questions, get off! And hope somebody finds you.*

"We're with you, coxswain!" some of the *Pendleton* crew hollered. After that, hardly anything was spoken except the silent prayers of the rescued and rescuers.

It should be noted that Bernie's decisions and the actions of the Coast Guardsmen indeed were responsible for getting the survivors off the *Pendleton*. But the superbly trained merchant mariners—their cool under

immense pressure—their willingness to take orders, and follow them, should also be factored into the success of this mission.

"We were just holding on," said Richard, who was crammed in the forward compartment with the crew. "They didn't say anything," though a few prayers were muttered.

The *CG36500* motored into the night and the Coast Guard crew was on the lookout for anything: lights, land or marked buoys. Several times the humble engine sputtered out and died. "I do remember going from the front to the stern because of an engine problem," Andy recalled. "The control that had to be operated to 'prime' the engine was very close to the hot manifold and you invariably burned your arm when doing the job." Andy remembered an extremely cramped engine room. "I do believe a few of the last survivors did go into the engine compartment, because it was warmer there and not much room on the rest of the boat."

"As luck would have it, we found a little buoy on Chatham Bar" and that small red light never looked so promising before. Unbelievably, Bernie and his crew had found their way back to their home port.

"It was the buoy on the inside of the Chatham Bar, at the turn marking the entrance up into Old Harbor," Bernie's memoirs stated. Bernie switched the radio back on:

> *I called the station after I got in over the bar and I told them I was rounding Morris Island and heading up the harbor and to have ambulances and help down at the pier for the survivors. I'm heading into the fish pier and coming down the channel between Aunt Lydia's Cove and the fish pier, and the pier was jam-packed full of people. As I looked up, I recognized many of them, many of the fishermen were there, there were little kids and women, and some of them had blankets, carrying all kinds of stuff. They helped the survivors off and scooped them up.*

"That must have been 9:00, 10:00," remembered Joe Nickerson, a carpenter and lifelong Chatham resident who high-tailed it to the fish pier that night.

Earlier that day Joe had heard the *Pendleton's* distress signal as the mortally wounded tanker floated by Chatham, its stern visible from

shore. "It would blow four times, then stop, four more times, then stop," remembered Nickerson.

Joe Nickerson went to fire chief George Goodspeed's home to report the distress call. Goodspeed in turn alerted the Coast Guard, and Nickerson says, "Bill Woodman was the radar man…and we heard conversations going back and forth."

"I never thought they'd make it, going over the bar," he remembered.

Nickerson figured seventy-five, maybe up to one hundred people, crowded onto the fish pier to watch the CG*36500*, her crew and survivors, limp into port. Dozens of warm hands reached for the shaken, cold *Pendleton* crew, with strangers wrapping other strangers in dark, wool blankets, shuttling them to vehicles for the short ride to the Chatham Lifeboat Station. Some *Pendleton* crewmen traveled to the nearby Chatham Station in Coast Guard trucks. "I think others went in people's cars, and

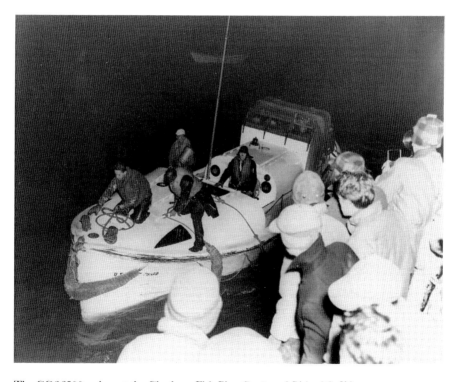

The CG*36500* arrives at the Chatham Fish Pier. *Courtesy of Richard C. Kelsey.*

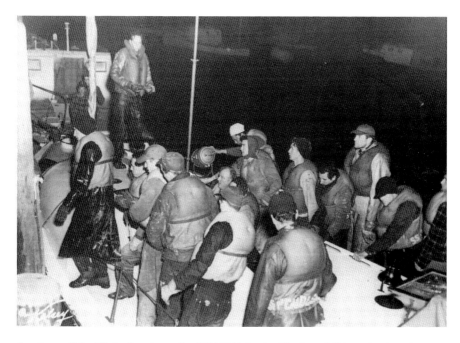

Survivors of the SS *Pendleton* leave the CG*36500* for the Chatham Lifeboat Station. *Courtesy of Richard C. Kelsey.*

they drove 'em up to the station. They were right there the whole time," Bernie remembered, "like the whole town was there."

"They piled them right out onto the dock and right into cars," he said. "I took two of 'em down to the Coast Guard Station in my '49 blue Ford sedan," recalled Nickerson. "They didn't say much; they were in shock."

"Long after thirty-four of the thirty-six men had left the boat, Webber stood there—exhausted, holding his head up with his elbow on the cockpit cover," photographer Dick Kelsey would say years later.

"It was my most poignant photo of the night—Bernie just standing there." Bernie does not remember leaving the CG*36500* or the drive back to Chatham Lifeboat Station.

Back aboard the CG*36500*, since Andy was the junior engineer, his duties included those of seamen, like tying up lines. "That was why I handled the bow line as we approached the fish pier with the *Pendleton* survivors. After the tie-up I stayed near the boat because I assumed we would put it back on the mooring," Fitzgerald recalled. After what

Bernie Webber and Ervin Maske on the deck of the *CG36500* following the harrowing rescue. *Courtesy of Richard C. Kelsey.*

the crew had just been through, it was in Andy's dutiful nature to wait to work again. "I hung around quite awhile until Bill Woodward approached me and asked me why I wasn't back at the station. I told him I was waiting to put the boat back on the mooring and he told me

that someone would take care of that and I should get into the truck with him."

Andy says the Chatham Lifeboat Station was a "mad house" with "people all over the place" when he and Woodward arrived there. "We got back to the station and we had hot coffee and sandwiches and news reporters were there," remembered Richard. "Doctor Keene from Chatham had come. I think they thought we were gonna come down with pneumonia to tell ya the truth, cuz we were all soaking wet."

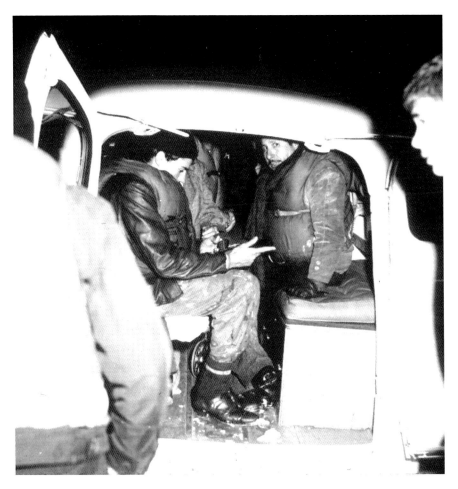

The trip from the Chatham Fish Pier to the Chatham Lifeboat Station took less than five minutes. *Courtesy of Richard C. Kelsey.*

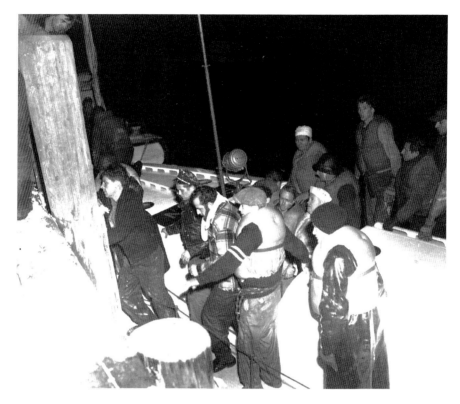

One by one, in near-shock and quite cold, the crew of the SS *Pendleton* departs the CG*36500* for the Chatham Lifeboat Station. *Courtesy of Richard C. Kelsey.*

Someone got Bernie a doughnut he desperately craved. Andy met up with Bernie, Richard and Ervin for coffee and doughnuts, and "boy, they were so good!"

The Chatham Lifeboat Station was a circus; pandemonium minus the elephant.

"As I passed through the mess hall I couldn't believe the commotion going on there," Bernie said in his memoirs. "*Pendleton* survivors were sitting, standing and lying around the room everywhere. Some were attended to by Dr. Carroll Keene, Rev. Steve Smith, Ben Goodspeed and others, receiving medical or spiritual attention as needed." Bernie saw the manager of Puritan Clothing in Chatham, Ben Shufro, measure *Pendleton* crewmen for new shirts and trousers. A Red Cross contingent led by Leroy Anderson helped as needed. The rescue was big news, naturally.

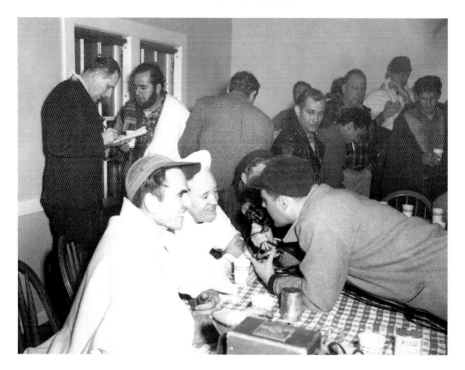

Radio reporter Ed Semprini interviewed SS *Pendleton* crewmen recovering from their ordeal at the Chatham Lifeboat Station. *Courtesy of Richard C. Kelsey.*

Ed Semprini of WOCB in West Yarmouth interviewed survivors and his interviews were aired nationally. "I was news director for WOCB in West Yarmouth...when we got to Station Chatham we found that all those men were not from the *Fort Mercer*, they were from the *Pendleton*," Semprini said.

In 1985, Bernie asked Semprini for his thoughts, which appeared in Webber's 1985 book, *Chatham: "The Lifeboatmen"*: "I recall the Coast Guardsmen, happy and proud that they had accomplished a near miracle.

"I recall speaking with them and I recall one, Bernie Webber, crying, because one of the *Pendleton* crew was lost. I believe he was a cook, a very heavy man, who slipped and fell into the boiling seas as he was attempting to get into the lifeboat," recalled Semprini.

Photographers snapped pictures of the scene.

"The *Pendleton* crew was tied up with people interviewing them so I didn't get a chance to talk to any of them," Andy remembered. Dr.

Henry P. Hopkins, Chatham's physician of many years was also there, and Nickerson recalls Hopkins as a "regular guy," a World War II veteran of Guadalcanal. "He was one of the kinds of doctors who told you what was wrong with you," added Nickerson.

The late photographer Richard "Dick" Kelsey composed his memories and observations that were published in Bernie's memoirs in 1985. "The kitchen area was a steam pit of moist steam radiators hissing...coffee urns steaming...soaking wet blankets and clothing everywhere...later I photographed Bernie and his three man crew, Maske, Livesey and Fitzgerald, enjoying coffee and doughnuts...looking happy to be alive and back with 32 grateful survivors."

Another lifelong Chatham resident, Richard Ryder, remembered that some *Pendleton* survivors weren't in the station fifteen minutes before the fainting began. They "just passed out," he remembered. "I suppose they were so relieved and keyed up," he offered. Sixteen of the *Pendleton* survivors hit the decks in a dead faint, Ryder added. "I'd never seen anything like it."

What happened to the survivors was a physical phenomenon the Coast Guard calls circum-rescue shock. During a crisis, blood pressure spikes. Only when the danger has passed will the blood pressure plummet and normal blood pressure levels return, sometimes causing sudden death, but usually only fainting. Fortunately, for the rescued merchant mariners, no one died, and all quickly came to.

To be on the safe side, several ambulances arrived at the Chatham Lifeboat Station to transport survivors to Cape Cod Hospital in Hyannis for treatment and observation where a young Dr. Forest Beam, who practiced in Barnstable village, was on duty.

"In those days we had to cover the emergency room...the night of the *Pendleton* affair I was assigned to be on call for the emergency room," recalled Beam. The call to expect the ambulances came in about 8:00 p.m. The legendary Cape Cod Hospital nurse Ethel Barton arrived to help and oversee the influx of patients and their care. Beam recounted that "the problem was exposure," and no doubt circum-rescue shock was also a likely cause.

Barton turned to Beam and said "the best way to get them warm is to stick their feet inside the pillow case of a feather pillow," he remembered.

They did so, and it worked. "I remember that night well because it was one of those cold, rainy, windy nights, and I had to go over to the hospital to help," clarified Beam.

In Chatham, while Bernie, Andy, Ervin and Richard filled up on hot coffee and sandwiches, the telephone at Silver Heels rang. Miriam Webber, still sick with the flu, answered the phone. John Stello, the fisherman and neighbor who had seen Bernie at the fish pier when the CG*36500* headed out for the *Pendleton* was on the other line.

"Did you know Bernie's a hero?" he asked.

Miriam, puzzled, answered, "A hero--why?"

Then John Stello told Miriam about the rescue.

Shortly after that, Bernie spoke briefly to Miriam. "I can only talk a few minutes," he said, adding, "I'm fine and I'll be in touch with you tomorrow." Exhausted, Bernie grabbed a bite and headed for his bunk.

From left: Bernie Webber, Andy Fitzgerald, Richard Livesey and Ervin Maske warm up with coffee and donuts at the Chatham Lifeboat Station. *Courtesy of Richard C. Kelsey.*

"All I had wanted was a cup of coffee and a good Cushman's doughnut," Bernie remembered.

Once he retired, Bernie's "thoughts and prayers were turned to those who this night remained at sea."

When Bernie woke on February 19, 1952, Webber found an open drawer full of dollar bills. The *Pendleton* survivors had tossed money into the drawer near the sleeping coxswain. The next day, Bernie asked Bosun Cluff about the cash, and Cluff said the money was his to keep as a reward for leading the rescue. Instead Bernie bought the first television station for the Chatham Lifeboat Station.

From February 19, 1952, onward, Bernie's life changed. "The next morning, staring at the ceiling above my bunk at the Chatham Lifeboat Station, I wondered if I had dreamed of being at sea in a storm or if I had actually taken part in the rescue of thirty-two men," Webber's memoirs stated.

Some call the rescue a miracle on several fronts: that Bernie and the crew Webber cobbled together—engineer Andy Fitzgerald, and able seamen Richard Livesey and Ervin Maske—had even survived; that the crew had even discovered the location of the *Pendleton*; that thirty-two men from the *Pendleton* had fit aboard the CG*36500* that had a maximum safety rating for only fifteen survivors; and that Bernie guided, and safely so, the *36500* back to Chatham's famous fish pier. It was a mission feat unequaled in Coast Guard history, and a mission still studied, researched and talked about today.

The *Pendleton* crewmen who survived were transported to Boston and, eventually, home. On February 19, Dick Kelsey was aboard the CG*36500* that went back to the bow of the *Pendleton*. "The seas were too dangerous to board," he said. "Later one body was found in the bow paint locker wrapped in burlap, rolled in sawdust and dead from exposure." Today, Bernie is immensely respectful at the mention of so many lives being lost on the SS *Pendleton*.

"Everyone on the bow died," he remembered.

Six days after the storm the CG36500 was dispatched at 0945 to the bow section of Pendleton *to remove the body of Herman G. Gatlin.*

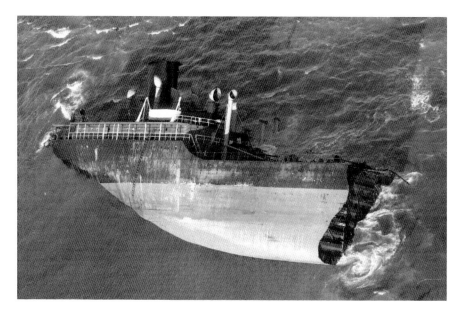

In the days following the demise of the SS *Pendleton,* photographer Richard C. Kelsey snapped this picture of the wreck.

The salvage crew from the tug CURB had found his body wrapped in rags and covered over with sawdust (normally used for oil spills) laying on a paint locker shelf where he evidently went after the ship broke in two to try to keep warm and survive. When the lifeboat arrived the salvage crew "tossed" his body over the side from high above into the boat...they refused to use the stokes-litter the Coast Guard crew brought out so that it could be lowered in a respectful manner. The treatment of the one body located...was a shock to a Coast Guard crew who had a greater respect for humans alive or dead.

That there were survivors was a reason to rejoice, but the knowledge that so many had perished was never lost on any Coast Guardsman at the Chatham Lifeboat Station. "With the loss of Myers," Bernie said, "the body in the bow meant a lot, just being able to see it returned to loved ones."

At a Coast Guard board of inquiry held in Boston on Thursday, February 21, at 11:30 a.m., eyewitnesses were questioned by a panel

comprised of the following individuals: Captain Walter R. Richards; Captain William W. Storey; Commander William J. Conley Jr.; Commander William C. Mahoney, recorder; and Lieutenant Commander Ellie L. Perry, a technical advisor.

One witness was David A. Brown of New York City, a Coast Guard–licensed engineer who served as the *Pendleton*'s first assistant engineer. In his testimony, Brown answered the nagging question of who was the last man off the *Pendleton*, debunking the tanker crew-fed rumor that it was Tiny Myers. "The third or fourth man from the last was unable to be rescued due to tremendous seas and was crushed against the side of the ship and was not seen again," Brown insisted. "I was the last man off the ship and no men left aboard. We were taken to Chatham Lifeboat Station and released the following day."

SURVIVORS AND CASUALTIES

The *Boston Herald* listed the names of the *Pendleton* survivors rescued by the *36500*, in order by rank, in its February 20, 1952 edition. Where available, titles and ranks were provided: Ray L. Sybert, chief engineer, age thirty-three, from Norfolk, Virginia; First Assistant Engineer David A. Brown; Second Assistant Engineer Edward A. Gallagher; Third Assistant Engineer Douglas B. Potts; Third Assistant Engineer Wallace P. Quirey; Mike Faifua, boatswain; Frederick Onno; Charles W. Bridges; Junior J. Hicks; James E. Young, pump man; Edward C. Brown, engineer room maintenance man; Tchuda W. Southerland, oiler; Vernon A. Collins, oiler; Frank Fateux, fireman; Aaron B. Povsell, wiper; Joseph W. Zezptarski, mess man; Albert L. Johnson, oiler; Henry Anderson, wiper; Margasito T. Flores, galley man; Rollo E. Kennison, deck maintenance man; Raymond G. Stelle; Lorand David Maillbo, utility man; Oliver Gendron, steward; Fred Baker, fireman; Alfred S. Baltazar, chief clerk; Arthur Schuster, fireman; Alfred S. Baltazar, chief clerk; Arthur Schuster, fireman; Domingo F. Garcia, mess man; Gerald Lee Russell, deck maintenance man; Eldon C. Hanan, deck maintenance man; Aquinol B. Oliveira, second cook; Carrol M. Kilgore, mess man; and Fred R.

Brown, wiper. The *Herald* listed George "Tiny" Myers as "Lost during rescue." In a report dated September 25, 1952, from the chief of the Merchant Vessel Inspection Division, H.C. Shepard, to the chief of the Officer of Merchant Marine Safety, the names of nine crewmembers aboard *Pendleton* who perished on February 18, 1952, were given: Master John J. Fitzgerald; Chief Mate Martin Moe; Second Mate Joseph W. Colgan; Third Mate Harold Bancus; Radio Operator James G. Greer; Seaman Joseph L. Landry; Seaman Herman G. Gatlin; Seaman Billy Roy Morgan; and Seaman George D. Myers.

Included in the same report is the suspected cause of the *Pendleton* disaster:

"In arriving at its determinations of the cause of this casualty the Board based its opinions on three principal factors which contributed mainly to the breaking in two of the *PENDLETON*, namely: (1) construction, (2) weather and (3) loading." The Coast Guard pointed to the "many points of stress concentration in the *PENDLETON*," which contributed to its demise. Weather was blamed, too. "The Board is of the opinion that the weather had a vital part in causing this casualty particularly the temperature and the sea…and the probable position of the vessel with reference to the direction of the seas would at times place the bow and stern portions of the vessel in the crests of waves with little or no support amidships." As for loading, the Coast Guard's report concluded an imbalanced cargo—with some tanks empty and others full—caused a weight shift that contributed to the accident. The report also stated, "The loss of George Myers during the evacuation of the stern section was not due to any lack of effort on the part of the Coast Guard, or to defective equipment on the tanker."

Through years of friendship with the authors, Bernie had always insisted "there were no heroics…it was a case of survival, not only for the survivors of the *Pendleton*, but for ourselves. We may have taken the chance and felt the need to go, and stick your neck out where it might be chopped off, but that was the job."

Chapter 5

SEEKING BELONGING
AND PURPOSE

Who was Bernie Webber? Just a young man seeking belonging and purpose, he would have said. For Bernie, joining the Coast Guard following a short stint in the merchant marine was his calling in life. Being in the service gave young Webber equilibrium and meaning. And nothing could please Bernie's father more. Bernie's father, the Reverend A. Bernard Webber, was a Baptist minister and Bernie admitted "I drove him crazy."

Bernard Challen Webber was born on May 9, 1928, the youngest of four boys born to Annie Knight and A. Bernard Webber. Bernie's wife, Miriam, remembers her mother-in-law in the kindest terms. "She was a real sweetheart." When Bernie was younger he'd pick his petite mother up and "twirl her around."

Bernie's father was strict and devoted to his family but was a man who kept his emotions close to his vestments. A pious man, Rev. Webber settled his young family in affluent Milton, Massachusetts, where by 1943 "my Dad was serving as the associate pastor at Tremont Temple Baptist Church in Boston, Massachusetts," Bernie's memoir recalls.

The family's move to the Boston suburbs coincided with World War II, and the three elder Webber boys shipped out with various branches of the armed services, leaving Bernie—a tall, lanky fifteen-year-old—at

home. "Brother Paul left with the first draft and served in the army's Twenty-sixth Division in Germany. Brother Bob served the U.S. Coast Guard. Brother Bill served the Army Transportation Corps and was off building the Alaskan Highway," he remembered.

By his own reckoning but without providing details, Bernie confesses that as a kid he was "easily led." But it's not like Bernie did anything drastically wrong, like break the law. In any case, through family connections and a patron, Bernie left for boarding school, Mount Hermon Preparatory at Greenfield, Massachusetts. He was strongly advised to study for the ministry. "Of course, I was not consulted," he said. A deacon at his father's church paid the tuition, and Rev. Webber picked up the cost of incidentals, but Bernie felt out of place there, especially in his brother's hand-me-down clothes. "With limited allowance, and neither scholastically nor athletically inclined, I wasn't a prime candidate for either Mount Hermon or the ministry," he would later write.

The kids from rich families worked as waiters in the dining hall, but the scholarship students and those from poorer families labored on the farm. Bernie, thin but strong, was a field hand who shoveled "dung on the farm, and also worked in the laundry." To his dying day, memories of the stench of the barn stayed with him: "My last class, a French class, was late, and I always smelled like a cow," Webber recalled. "The French teacher would always make note of that." "I wasn't too happy with the setup, but I was moving along," Bernie said.

That all changed when a buddy from home, Milton Anderson, smashed his father's car and ran to Mount Hermon to see Bernie and hide out until the parental storm cleared. Bernie could not hide Milton in his room, "because my roommate would have squealed," so instead Bernie knew "another fella" who agreed to conceal Milton, who spent a few days on the Mount Hermon campus.

Maybe it was Milton's fault, or maybe Webber knew he wasn't cut out for prep school, in any case, Bernie quit the exclusive boarding school, and along with "we fled through the cornfields in Northfield, Massachusetts, and went home."

The senior Webber confronted Bernie about his son's future. The reverend struggled with giving his youngest son guidance. Young Webber solved his

own problem. Bernie had heard that teenagers were accepted at sixteen as merchant seamen. He begged to go. "I talked my father into signing for me and he was glad to do it, as I was so rebellious and such a problem," Bernie said. Webber was not a troubled delinquent during this stage in his young life, merely a kid needing stern direction. So at the age of sixteen, Bernie was on his own and would soon be halfway across the globe, working.

Once basic training in the merchant marine was over Bernie shipped to Panama to board the SS *Sinclaire Rubiline*, "a T2 Tanker." Coincidentally, a T2 tanker would figure prominently into Bernie's life within a few short years, but not because of his time in the merchant marine. "From the ports of Aruba and Curacao in the Caribbean we carried gasoline to the South Pacific in support of the war effort," Bernie said.

In 1946, Bernie enlisted in the Coast Guard, almost on a fluke and whim. "I wanted to find another berth in the merchant marine to avoid the army, as I was approaching the draft age. Since shipping in the Atlantic was slow, you could turn down two ships if you didn't like what you heard," he explained. "But the third one you had to take," which was what brought Bernie to Constitution Wharf at midday in Boston.

"They shut down every noontime at the shipping center." Bernie looked for a place to eat lunch. He strolled to Constitution Wharf near where the Coast Guard was based and saw a sign that read "The Coast Guard Wants You." Bernie knew the Guard issued seaman's papers so in he went. What happened next is almost comical.

There a second-class petty officer sat "with his feet up on the desk eating his lunch" and said, "What the hell do you want?"

Bernie said he saw the sign outside.

"What the hell do you have to offer the Coast Guard?"

The sign outside, Bernie again mentioned.

"Well, that doesn't necessarily mean you!"

"I'm a merchant seaman," Webber replied.

"The minute I said that he perked up, took his feet off the desk and told me to sit down," Webber later recalled.

The enlistment papers required his father's signature and once Webber's father signed them, Bernie said, "Here we go again," and off to Curtis Bay, Maryland, he went for basic training.

Webber's first assignment after leaving basic training was as keeper of Highland Lighthouse at North Truro. It was the perfect way for a teenager to begin a new career: in a quiet place, with structure. Within six months Bernie was transferred to the Gay Head Lighthouse on Martha's Vineyard, and this was still in 1946.

That October, Bernie spent a few days at the Chatham Lifeboat Station before moving to his new duty assignment at Gay Head on the Vineyard's southwestern corner. Webber was a mere eighteen years old. "I would get to know the Town of Chatham, become acquainted with the lifeboat station, and make some personal decisions about my future," he wrote. "I felt an attraction to Chatham…and sensed there was a reason I had been brought to this place." It was here in this historic town, driving around with a colleague in a Coast Guard pickup truck during the layover to the Vineyard, that Bernie caught his first glimpse of the *CG36500*. "I asked the driver of the truck what that boat out in the harbor was. He said it was a thirty-six foot Coast Guard motor life boat. That particular boat in time would become one of the most important factors in my life and the lives of many others," according to Bernie's memoir published in 1985. But Bernie's destiny with Chatham would have to wait several years because Bernie would spend the next three years at the Gay Head Lighthouse earning less than one hundred dollars a month. What he loved about the place was its solitude, cheery locals and a landscape that changed with the seasons. And it was at the Gay Head Lighthouse that young Webber felt truly comfortable in the Coast Guard.

Through the lens of an old man Bernie remembered his tour on the Vineyard fondly. "It is indeed a place of wonderment: high cliffs of colored clay, streaks of yellow, black, brown red and white encompass the place, on a sunny day gives the appearance of being on fire." Bernie admitted being stationed at Gay Head could be "lonely and depressing." Winters were the worst. Nor'easters typically lasted three or more days. With little to do, the days seemed endless. The lighthouse is wicked isolated from the rest of the Vineyard, with Vineyard Haven, Oak Bluffs and Edgartown a long way off. Only a few people lived nearby: the lighthouse keeper, his wife and a "few Gay Head Indians scattered about in small houses," Bernie once wrote.

If the location proved remote, Bernie's collegiate connections were not, and young Webber loved working there. "I had the privilege of serving with one of the last of the old time Coast Guard surfmen, Joe Walsh," Bernie remembered. Joe was the first father figure Bernie encountered in the Coast Guard once basic training was over. Joe, who was five-foot, six-inches tall and weighed about "110 pounds soaking wet," signed up with the Coast Guard in the 1920s and was one of Bernie's first mentors in the Coast Guard. To work with a man who bridged the service between the former Life-Saving Service and the new Coast Guard was something Webber cherished as he aged. Walsh was in the Coast Guard before motorized vessels were used. "I wondered how this slight figure of a man could pull an oar in a surfboat yet from all reports, Joe more than held his own."

These interactions with senior Coast Guardsmen left an indelible impression on Webber. Bernie was growing up, and with each new duty station Webber realized the Coast Guard was his passion. That restless teenager had found in the Coast Guard his calling, his primal cradle that was the sea and his future. After three years on the Vineyard and a tour aboard a cutter in the North Atlantic, Bernie was transferred to the Chatham Lifeboat Station. Webber's premonition that he would indeed return to Chatham had come true; Bernie immediately realized the town was special. Chatham is a storied place at the elbow of Cape Cod; its pages were part of the earliest chapters of the storybook of New England colonial history.

Famed explorer and Frenchman Samuel de Champlain sailed into what is now Stage Harbor in Chatham in October 1606 and he named the region Cape Malabar. Within two weeks the local Natives, the Monomoyick, and the Europeans fought one another, and both sides suffered casualties before de Champlain swiftly sailed off. Fifty years later, an Englishman, William Nickerson, bought land from the Native sachem, Mattaquason, in what is now Chatham. For "one shallope ten Coates of hacking cloth six kettles 12 axes 12 hoes 12 knives forty shillings in Wampam a hatt and 12 shillings," equaling about forty acres—roughly four square miles—from Mattaquason around 1650. On June 11, 1712, the Town of Chatham was incorporated. By 1810, the federal census

counted 1,334 residents. Chatham men served in the War of 1812, working mostly as privateers or in service to the navy. Fishing resumed in earnest after the blockade ended. "In 1837 the town had twenty-two vessels in the fisheries, yielding annually fifteen thousand quintals of cod and twelve hundred barrels of mackerel," noted Simeon Deyo in his history of Barnstable County. Cranberry growers and salt manufacturers also saw their industries grow.

Three lighthouses operated for the safety of mariners. The Stage Harbor Light began operating in 1880 and was deactivated in 1933. In 1849, the Monomoy Point Light was activated, but decommissioned in 1923. The Chatham Light, at the Chatham Lifeboat Station, was established in 1877 and automated in 1982 under the auspices of the Coast Guard and is open to the public only during special open houses. In 1937, the railroad station closed when bus service began in Chatham, according to the town's website. The rail station, once so necessary and popular, sat empty until the town was given the structure and officials turned it into a public museum.

Bernie's transfer to the Chatham Lifeboat Station followed a tour on the Vineyard and aboard "Coast Guard cutters on the North Atlantic Weather Patrol," Webber wrote. So far his Coast Guard career had included two stints at lighthouses and an at-sea tour, and he was barely twenty. All along Bernie suspected he'd wind up at Chatham one way or another.

> *As I arrived at Chatham, the town appeared pretty much as I had remembered it. The same quaint place, with a clean atmosphere and neat Cape Cod style homes. Perhaps there was a new shop or two on Main Street, or a few more fishermen working from the Fish Pier, departing out of Aunt Lydia's Cove, crossing Chatham Bars daily in pursuit of fresh fish.*
>
> *Alton Kenney's boatyard was busy where he and Elisah Bearse took care of the ills of the Fleet. The Sou'Wester and Jake's remained as places for blowing off steam. The Dutch Oven on Main Street was available for those who wanted good coffee and conversation.*

The Chatham Lifeboat Station was as unique as Chatham itself. A lighthouse was in the front yard. There used to be two, hence the nickname Twin Lights of Chatham, but one light was moved to Eastham and renamed Nauset Light. "The station equipment was spread out all around the town, necessary due to the geographic arrangement of the town and surrounding waters," Bernie clarified.

"One lifeboat was kept on a mooring out in Old Harbor. The other lifeboat and the picket boat were kept on the moorings at Stage Harbor. This was done so that access to the Atlantic Ocean and Nantucket Sound would be readily available under all circumstances," Webber added.

One of Bernie's first mentors in the Coast Guard was First Class Boatswain's Mate Leo Gracie who often drove the thirty-eight-foot picket boat used in search and rescue missions. "He appeared to be proud of his status as an operator of rescue vessels. I decided then and there that I, too, wanted to become one of those boatswain mates of the Coast Guard that operated rescue vessels," Webber noted in his '85 memoir.

Webber soon had his chance to work alongside Gracie. Bernie's first rescue at Station Chatham was helping with the stranding of the USS *Livermore* in 1949 at the age of twenty-one. The vessel carried mostly navy reservists and became stranded in a calm sea under a full moon. "For some reason when passing *Stonehorse* Lightship she did not make the necessary course change to the right which would take the ship safely up the Pollock Rip Channel passing between the buoys with their lights flashing," Bernie recalled. "Instead, the *Livermore* moved straight ahead and eventually came to a halt," resting on Bearses' Shoal off Monomoy.

Gracie picked Webber to go with him, and reaching the *Livermore*, Gracie and his crew waited for larger vessels such as tugs and navy salvage ships from the Boston naval shipyard to arrive to help. Chatham Lifeboat Station's picket boat towed hawsers across the water several times and transported supplies and personnel between the vessels until the *Livermore* was free and clear.

Several more assignments landed on Bernie's lap before he was qualified to operate rescue boats—his chief goal—and subsequently go out on the *Pendleton* rescue. As a coxswain Bernie supervised the Loran

unit—a monitoring facility—at the Chatham Lifeboat Station, then soon after, he went to the Monomoy Point Lookout Station.

Bernie's boss was the kindly Alvin E. Newcomb, a chief warrant officer with thirty years' service. Webber loved the guy. "We affectionately referred to him as 'Mother Newcomb' for several reasons. His only child was his daughter, Evelyn. As a result his crew at the station became adopted sons." Newcomb did not care for trouble among his boys: "At night Alvin Newcomb would make bed checks on his crew and roam the station yard with a flashlight in hand. Smoking the pipe that was forever in his mouth, his presence was announced long before his arrival," Bernie would later write.

"I think he planned it that way so as not to catch any of the crew that might be lurking around the station yard, in the dark, with some of the local girls."

Indeed. In his early days at the Chatham Lifeboat Station Bernie was courting a local girl. Miriam Pentinen was Wellfleet born and bred on Cross Street and daughter of Finnish immigrants Olga and Otto Pentinen. She had met Bernie on a blind date, and they went to Bob Murray's Drugstore on Main Street in Wellfleet. Bernie drove his 1939 two-door Plymouth sedan. "We left the drugstore and went to a place called Ma Downer's out in South Wellfleet," Bernie would write years later. "There wasn't any place else to go in those days as they rolled the sidewalks up in the Town of Wellfleet at seven p.m. Ma Downer's was just a shack, a small place where one could sit and have a cup of coffee or drink a beer." Bernie said the date was not terribly exciting for any of them, including the other couple on the double date. "We just sat around talking and carved our initials on the wooden table."

Bernie, however, grew smitten when he and Miriam kissed and, Bernie remembered, "Bells began to ring in my head." And so it began: an honorable, earnest courtship between two young, vibrant people. Miriam and Bernie dated through the winter of 1950. An engagement came several months later. They married at the home of Bernie's parents, the Reverend A. Bernard and Annie Knight Webber, on July 16, 1950. "It was strange to have my father officiate, and was even somewhat more awkward for Miriam as she knew the minister would now be her father-in-law," Bernie recounted. The groom was twenty-two.

Mrs. Bernard C. Webber—the former Miriam Pentinen of Wellfleet—a year after their 1950 wedding. *Courtesy of Bernard C. Webber.*

Bernie's marriage to Miriam grounded the young Coast Guardsman, whose formative years were challenging to his strict father, a Baptist minister. "Once married to Miriam I also felt truly united with Cape Cod," Bernie recounted in his memoirs, published in 1985. "At first we took up residence in a little upstairs apartment located in a building next door to the curtain factory in Wellfleet. I was by myself most of the time," Miriam recalls, since her new husband pulled many ten-day stints at the Chatham Lifeboat Station. The Webbers moved to Chatham and rented a nine-room house called Silver Heels.

It was, Miriam recalls, "nothing elaborate," but the living and dining rooms were comfortable, the latter having a tin ceiling with cracks in it and the occasional mouse peering through. Bernie and Miriam would raise two children, Bernard Jr. and Patricia "Pattie."

In the early 1950s, when Bernie Webber brought his Wellfleet bride, Miriam, to Chatham, they found a community of caring, openness and

Bernie and Miriam on their wedding day on July 16, 1950, in Milton, Massachusetts. *Courtesy of Bernard C. Webber.*

a civic clan connected to the sea. When Bernie and Miriam married and settled at the elbow of Cape Cod, Chatham then was not what Chatham is now, with swanky shops and a high tax base. Then, the town revolved around its fishing piers, and that's the Chatham Bernie found when he returned in 1950 for a two-year tour at the Chatham Lifeboat Station.

In April 1950, a few months before his wedding, in an early spring nor'easter, the fishing dragger *William J. Landry* was foundering near the *Pollock Rip* lightship. Guy Emro, officer in charge (OIC) of the *Pollock Rip*, spoke to the skipper of the *Landry* and alerted Alvin Newcomb. The Chatham Lifeboat Station dispatched a lifeboat, and in the meantime the lightship crew made ready a hawser to attach to the *Landry*. Fate, however, conspired against all good intentions. The hawser idea failed. Newcomb ordered Chief Boatswain's Mate Frank Masaschi to take two other men, including Bernie, to Stage Harbor, row the dory out to the mooring of the lifeboat *CG36383*, then hightail it to the *Landry*.

Though the *CG36500* at the fish pier was closer, Newcomb thought crossing the bar in a nor'easter would be too dangerous, so they opted for the longer, but safer journey in the *CG36383*. Twice the dory rescue crew rowed to get to the *CG36383*, but they capsized. The only recourse was getting back to Station Chatham, warm up and change and launch the *CG36500* from Old Harbor and take their chances crossing the bar. Back at the station, word came from the *Landry* that the vessel was about a half mile from the *Pollock Rip*, but it was a losing battle. The hawser was ready but the *Landry* was not close enough to grab it.

The storm worsened and the vessel went under for the last time, with all hands. The loss was devastating.

"At Chatham, in the watchroom, there was stunned silence. Four bedraggled men stood quiet, heads down, staring at the floor," Bernie remembered. "Their bodies still felt the pain and weariness of their earlier attempts to assist the *Landry*."

Chatham Bar was in constant motion, always changing, sands shifting and swirling. The shoals shifted making the bars awful to navigate. Breakers could "pitch-pole" a fishing vessel, which, according to Bernie, was the worst thing that could happen. "The power in the waves could pick a fishing vessel up by the stern and turn it end for end, over and over, sometimes several times, until it landed on the beach in the harbor upside down." Webber says pitch-poling meant certain death for fishermen. This is what happened to Archie Nickerson and Elroy Larkin in their forty-foot novi-boat, the *Cachalot*, on October 30, 1950, below Morris Island in Old Harbor.

Bernie, Chief Frank Masaschi and Stan Dauphinais drove to the fish pier to board the CG*36500* and investigate. They pulled Elroy Larkin's body from the waters of Old Harbor onto the lifeboat but the body of Arch Nickerson was never recovered. Chatham was a small world. Arch's daughter Beverly later married a seaman at Chatham, Richard Livesey, one of the four men aboard the CG*36500* the night of the *Pendleton* rescue.

That winter, Livesey helped rescue eleven crewmen from the New Bedford Scalloper *Muriel and Russell*, which ran aground at North Beach. The crew at Station Chatham used the DUKW, an amphibious relic of World War II, to rescue the crew.

Alvin Newcomb was transferred from Chatham to Woods Hole shortly after that rescue. His replacement as OIC at Station Chatham, Daniel W. Cluff, came from Chincoteague, Virginia, and spoke with a discernible Southern accent. Cluff and Frank Masaschi butted heads, and before long Frank's request for a transfer to Woods Hole came through. Chief Boatswain's Mate Donald Bangs replaced Masaschi as OIC at Chatham and got along well with Cluff, so peace was restored there. Bernie would eventually work again with Newcomb and Masaschi in Woods Hole.

Up until February 18, 1952, Bernie Webber spent six years in the Coast Guard, and he would need every one of those days to prepare for what came next in his young career. So far he was lucky to have had four father figures guide his early Coast Guard career: Joe Walsh, Leo Gracie, Alvin Newcomb and Frank Masaschi.

SPRING 1952

In the weeks and months following the *Pendleton* rescue, Webber evolved into the Coast Guard's "hero poster boy." And he was never quite comfortable with the moniker or new public relations duties he was assigned.

In the 1950s, as America slid past the postwar years into prosperity and peace, the mentality and culture of the armed forces was to tout its heroes. Bernie made numerous appearances on behalf of the Coast Guard following the *Pendleton* rescue. There were "many talks to the Kiwanis and Rotary Clubs around Cape Cod and Boston, and the Propeller Club in Boston," remembered Bernie. Webber stayed at the venerable Touraine Hotel in Boston to take part in Armed Forces Day activities. He traveled to Baltimore, Maryland, and lodged at the Great Southern Hotel for the American Legion Medal of Valor Banquet where he was honored as the Coast Guard Man of the Year in 1952. There were many photo ops with "Senators, Commandant of the USCG, other Admirals and Generals," noted Bernie.

On April 15, 1952, Bernie received an invitation from Edward R. Mitton, president of the Jordan Marsh Company, to "be one of our Head Table guests at the Jordan Marsh luncheon" held on April 28, "in honor of Cape Cod and the Islands, and including a salute to Coast

Left: A Coast Guard portrait of Bernard C. Webber as a Boatswain's Mate First Class. *Courtesy of Bernard C. Webber.*

Below: Bernie Webber (far left) at a Boston Kiwanis Club Luncheon in 1952. *Courtesy of Bernard C. Webber.*

Bernie Webber awaits a public relations assignment on behalf of the Coast Guard at the Touraine Hotel, Boston, in 1952. *Courtesy of Bernard C. Webber.*

Guard personnel on the Cape." Mitton presented Bernie with the Award of Merit at the event held at the Parker House in Boston.

On May 14, 1952, twenty-one Coast Guardsmen, including Bernie, Andy, Ervin and Richard, were honored for heroism for the rescue of seventy men from the *Fort Mercer* and *Pendleton* tankers. The Coast Guard's Gold Lifesaving Medal, which is the Coast Guard equivalent to the Medal of Honor, was given to each *CG36500* crew member by the Under Secretary of the Treasury Edward H. Foley.

Yakutat's ensign Kiely would be the only other Coast Guardsman to receive the coveted Gold Lifesaving Medal for the *Pendleton–Fort Mercer* rescues. His four other Monomoy boat crewmen would receive the service's next highest award for bravery, the Silver Lifesaving Medal.

At the decoration ceremony on May 14, 1952, Vice Admiral Merlin O'Neill delivered the following remarks:

February 18 and 19 always will be remembered in Coast Guard history. On those two days a nor'easter swept New England. It was bitter cold…with snow and sleet and howling winds. East of Cape Cod 70-knot winds and 60-foot seas battered merchant vessels which had not been able to make port. This was the setting for the Coast Guard drama which we review here today. Two larger tankers appeared on the scene—the SS Fort Mercer *and the SS* Pendleton. *Forty miles apart, they met the full and awful force of the storm. They broke in two on the morning of February 18…and the four separate hulks were swept along at the mercy of the sea. Survivors were marooned on each hulk…a total of 84 half-frozen men whose chances for rescue seemed impossible. The story of how 70 of these men were snatched from the elements and delivered safely ashore made headline news for several days. We have gathered here today to honor some of the men who took part in the* FORT MERCER– PENDLETON *rescue operations. I say some of these men because their individual exploits were outstanding. But we should not forget the much larger number of their shipmates whose skills, courage and devotion to duty went unnoticed in the overall operation. I am proud to say that it was the teamwork of all Coast Guard units involved that made possible the exceptional exploits that we note here today. As to individual exploits, you will hear the citations read shortly. In reality, these 21 men faced four separate rescue operations. Each operation offered special problems. But each held the same danger from hulks that tossed like corks in the towering waves. These men went about their duties drenched by icy water, without food for hours at a time… and with death riding on every wave. The operations were unique in Coast Guard history, and called for the skillful use of all types of rescue equipment…of cutters and small life-boats, of an airplane, a sea-going tug; of rubber life rafts, radar, scramble nets and exposure suits. But most of all, the situation called for raw courage and skill of the highest order—backed by true Coast Guard teamwork! To you men here, and to your shipmates, let me say that the entire Coast Guard is very, very proud of you.*

Spring 1952

Only twenty-four with six years of Coast Guard duty behind him, Bernie itched to get back to the Chatham Lifeboat Station to work, despite the honors being bestowed upon him. "I asked for a transfer out of Chatham shortly after *Pendleton*," Bernie remembered, to follow Chief Frank Masaschi, who did not get on with Bosun Cluff. Frank, however, "didn't know what he was getting," said Bernie. "I was second in charge of the CG Patrol Boat CG*83388*…as the Coast Guard was sending me everywhere on PR missions Frank had to do extra duty on board the boat as I wasn't available to relieve him," he recounted. Masaschi was the officer in charge of the CG*83388*, and Chief Warrant Officer Alvin E. Newcomb was the executive officer of the Woods Hole Coast Guard base, Bernie wrote in his memoirs.

U.S. Coast Guard commandant Merlin O'Neil and Boatswain's Mate First Class Bernard C. Webber at the Great Southern Hotel in Baltimore, Maryland, where Webber received the American Legion Medal of Valor and Coast Guardsmen of the Year for 1952. *Courtesy of Bernard C. Webber.*

U.S. Coast Guard commandant Merlin O'Neil shakes the hand of Bernard C. Webber at the Great Southern Hotel during an award ceremony. *Courtesy of Bernard C. Webber.*

Bernard C. Webber was honored at the American Legion Dinner in Baltimore in 1952. *Courtesy of Bernard C. Webber.*

Spring 1952

Miriam Webber (far left) accompanied her husband, Bernard Webber, to the American Legion Dinner in Baltimore in 1952. *Courtesy of Bernard C. Webber.*

In remembering Masaschi, "it didn't sit well with him or the crew for me to be gone so much." That must have stung Bernie since Masaschi was one of his mentors and father figures. Bernie was reassigned to the Chatham Lifeboat Station in July 1954, shortly after Frank Masaschi and Alvin Newcomb retired. "However, they both lived in Chatham and I would be able to visit them and continue to take advantage of their counsel and encouragement," Webber noted. Whatever friction the rescue and Bernie's PR trips for the Coast Guard caused in his relationships with Frank and Alvin were evidently repaired.

Bernie had since moved his young family, which now included Bernard Jr., from Silver Heels in Chatham to a little house he and his father-in-law built on Oak Street in North Eastham. Bernie continued to use the *CG36500* on search and rescue missions, the vessel at ease under his command. The rescue of fisherman Joe Stapleton in the late winter of 1955 off Morris Island near Chatham's bar was, in Bernie's word, "uncanny."

A young Coast Guard hero, Bernard C. Webber, addresses the audience at the Baltimore event. *Courtesy of Bernard C. Webber.*

Bernie, aboard the CG*36500*, found Stapleton's fishing boat underwater, and there was no evidence Joe was still living. In Bernie's memoir he wrote "On her own the CG*36500* veered out of the circle and headed in a southerly direction. I didn't pay much attention and didn't bother to change its new course…the amazing part of the story is that the CG*36500* on its own, unattended, not only led us to Joe's boat but later to Joe. Perhaps this could be another reason Joe never talked about the matter. I think he felt that it was a matter between himself, the CG*36500* and God."

Bernie was promoted to chief boatswain's mate shortly after the Stapleton case and he headed for a new duty station at Nauset Lifeboat Station in Eastham where he served as officer in charge, his first official leadership position. Webber was thrilled with the promotion, and on the plus side Nauset Lifeboat Station was fairly close to home. But "in

Edward R. Mitton (left), president of the Jordan Marsh Co., presents Jordan's Award of Merit medals to heroic Coast Guardsmen for outstanding bravery in the *Pendleton* disaster. Mitton gives medals to (from left) Captain W.R. Richards, chief of staff, First Coast Guard District, who accepted for eight of ten men unable to attend; Bernard C. Webber; and Daniel Cluff of the Chatham Lifeboat Station. *Courtesy of Bernard C. Webber.*

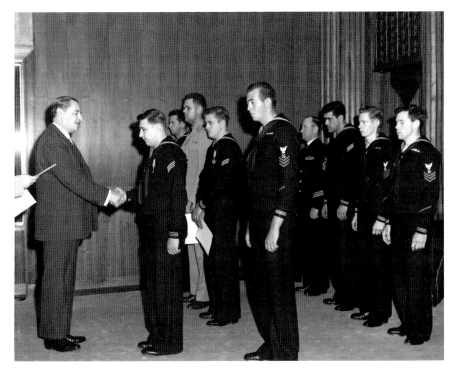

Under Secretary of the Treasury Edward H. Foley congratulates Seaman Ervin Maske after presenting Maske with the Gold Lifesaving Medal in Washington, D.C., in 1952. Behind Maske, from left in the first row are: Engineman Second Class Andy Fitzgerald; Ensign William R. Kiely Jr.; Seaman Richard Livesey; and Boatswain's Mate First Class Bernard C. Webber. In the second row: Chief Bosun Mate Donald H. Bangs; Seaman Richard J. Ciccone; Engineman First Class Emory H. Haynes; and Engineman First Class John F. Dunn. *Courtesy of Bernard C. Webber.*

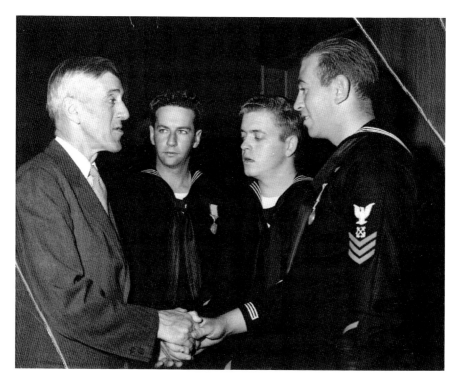

Massachusetts senator Leverett Salstonstall shares a few words with three of the CG*36500* Gold Medal crew: Andy Fitzgerald, Richard Livesey and Bernard C. Webber. *Courtesy of Bernard C. Webber.*

the back of my mind I knew, somehow, once again, I would return to Chatham," he would later say.

One of Bernie's leadership qualities that always served him well was his ability to relate to others and this Webber handled wonderfully. One day in 1955, someone screamed at him, "Chief, Hendry's up in the tower hanging onto the outside rail threatening to jump… says he's going to commit suicide!" So much for this duty station being known as the one where "nothing ever really happened."

Bernie flew from his office chair down the hall, out the front door and across the porch, looked up, and sure enough saw the station cook, a seaman named Hendry, "with one leg hanging over the railing of the lookout tower some forty feet up in the air mumbling something, appearing every bit ready to jump from the lookout tower."

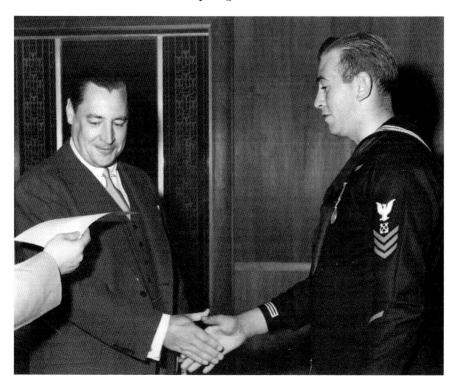

Boatswain's Mate First Class Bernard C. Webber, twenty-three, is congratulated by Under Secretary of the Treasury Edward H. Foley after being presented with the Treasury Department's Gold Life Saving Medal in Washington, D.C., for "extreme heroic daring" in the *Pendleton* rescue. *Courtesy of the U.S. Coast Guard and Bernard C. Webber.*

Bernie didn't know what to do. And not helping matters were other seamen shouting "jump Hendry, jump!" Bernie knew that if Hendry jumped, that was the end of his Coast Guard career, and plus, he did care about each one of his men. Hendry was upset that his fiancée had dumped him and ran off with someone else. Bernie yelled back the first thing that came to his mind. "Is that all that's bothering you? Well, go ahead and jump if that is what you want to do, but remember just one thing, if you do, you've got to clean up your own damned mess!" With that, Bernie turned on his heels and walked back to his office. OIC—Officer in Charge—Webber sat in his chair, staring straight ahead, "feeling drained and shaken by the experience and not believing what I had said and done." A few minutes later a contrite Hendry appeared at his door. "What do you mean, Chief, I've got to clean up my owned damned mess!?"

For a moment no one spoke. Bernie stared hard at Hendry, who stared down Chief Webber with fiery eyes. Authority versus defiance. "We were at an impasse until we both started laughing at the same time and we laughed and laughed until tears streamed down the cheeks of our faces, the tension broken, crisis over," Bernie later said.

Bernie's career in the Coast Guard was as varied as a daily newspaper. By the time he would retire in 1966, Bernie experienced the full breadth of the Coast Guard, serving aboard cutters, on a lightship, at lifeboat stations and lighthouses. Along the way, just by being himself, thinking on his feet and leaning on his own gut instinct, Webber had learned to lead himself and other men. By all accounts, Bernie earned the respect the seamen under his charge. Bernie didn't lead by a formal book, rather by his gut and his inherent compassion.

After serving at Nauset Lifeboat Station, Bernie accepted a transfer to the Race Point Lifeboat Station in Provincetown where he served as officer in charge in summer 1955. Webber loved it there and did a little of everything. Webber, then twenty-seven, was cleaning out a closet when he stumbled on several hundred small packets of World War II-era pro-kits. These kits contained germicidal soap, sanitary paper and a small tube of germicidal cream designed to prevent venereal diseases in service members. Frighteningly long past their effective due dates, Chief Webber wanted the kits tossed.

Joe, a local character who operated a Beach Taxi and Fishing Tackle business near the Race Point station, had stopped by the station and saw that Bernie was about to toss the kits, offered to dispose of them. Joe was well known to local Coast Guardsmen. "With a couple of small trailers, one he lived in, the other, he used as a fishing tackle shop along with three Jeep vehicles he sold tackle and took people on rides down the beach over the dunes to Race Point Light, and back again," Webber remembered. Joe was disheveled and wore wool shirts in the summer. He wore cowboy boots every day. But Joe was anything but poor. Bernie said he owned a huge house—"a beautiful home—a few miles out of Provincetown toward North Truro at Pilgrim Springs located high on a hill with panoramic views of the sand dunes of Peaked Hills, Provincetown and Cape Cod Bay."

A few days later, Bernie looked out his window to see Joe selling the old kits, three for a buck, and a sign that read: Fishing Tackle Cleaning Kits and Reel Lubricant. Guaranteed for the Germicidal Cleansing and Lubrication of Your Rods and Reels. Bernie laughed his head off, and Joe continued to sell the cleaning kits.

After Provincetown, Webber was transferred to the Coast Guard tug, the *CG64301*, based in Southwest Harbor, Maine. Once the Maine tour ended, Bernie was assigned to the Nantucket Lightship in 1958 that nurtured a lifelong passion for these floating beacons, which the Coast Guard discontinued in the mid 1980s. Lightship duty wasn't his first choice, but he needed to return to Massachusetts to be near a terminally ill family member. Funny thing was Bernie had heard rumors that lightship duty equaled punishment and "others considered such duty degrading." When "arriving at my new assignment, members of the lightship crew wanted to know as I was stepping aboard 'what I had done to foul up?'" Clearly the inference was that "I must have done something pretty bad to deserve the assignment to the Nantucket Lightship."

Following that tour of duty, Bernie had returned to the Chatham Lifeboat Station a third and final time, as officer in charge, far and long from his earlier tour as boatswain's mate in 1952. As OIC every night Webber went up to the lookout tower before turning in, chatted with the man on watch, checked over the equipment, watched for the familiar blinking lights of the Aids to Navigation. If all was in order, Webber hit the sack.

Bernie worked for Chief Warrant Officer Merritt O. Wright, the group commander, whose position was temporarily based out of Chatham. M.O., as he was called, was from Maine, a salty character with a sharp crew cut and a cigar never far from his mouth and a man who took no prisoners. One time, over a stretch of two days, Bernie and his crew had little sleep during a nor'easter that had blown straight for three days. Finally, Bernie caught some sleep, but the moment he shut his eyes the phone rang on a table near his bed.

Half awake, Webber answered, "Chief Webber speaking."

"Is that you?" M.O. barked into the phone.

"Ay'uh," Bernie replied, in that familiar Maine way of replying yes.

"That's what I thought you said!" M.O. shouted into the phone, slamming the receiver moments later with a bang in Bernie's ears. Chief Webber laid his head down on his pillow and tried to nap. He didn't think too much about M.O.'s tantrum since the warrant officer was known to fly off the handle frequently.

A few minutes later Wright bolted into the room and slammed the door against the wall. Bernie sat up, "scared out of my wits," he recalled. Wright stood in front of Webber, hands on hips, nostrils flaring like an enraged bull, and his crew cut spiked toward the ceiling. "What do you mean saying 'Yeah' to me? I'm your God damned commanding officer and you don't ever say yeah to me! You say 'yes' or 'yes, Sir.!'"

Bernie needed to think fast.

"Sir, you hail from the great state of Maine and as you know I also have a Maine heritage. I was only saying 'Ay'uh' meaning yes, you know I would never say 'yeah' to you, Sir." Warrant Officer Wright stood there, thinking, not knowing whether to get pissed or let the infraction slide. Bernie respected senior officers; he was good to his men, he was a hard worker, but Webber didn't always keep his mouth shut; his saving grace was his ability to scramble out of a tight spot.

Quickly M.O. calmed down and then he said "I thought you were saying 'yeah' and you know I won't stand for that. OK, get some rest." And with that, Bernie shut his eyes yet again and went to sleep.

Then there was the time Bernie thought he'd play a trick on the wise-cracking postman who delivered the mail just after lunch on the mess deck every day. Webber had a wicked sense of humor. Gene Love always had a snide remark about Shallow Water Sailors, all in good fun, of course. Bernie, still officer in charge of the Chatham Lifeboat Station, decided to spice things up, so one day on Chief Webber's orders his assistant, Ed Ferreira, hauled out the Lyle Gun, the big brass cannon displayed in the station's main hall just inside the front door used for Breeches Buoy rescues. "I then put a small charge of powder down the bore, placed the blank cartridge, slipped the clip under, and ran the lanyard along the floor to my office. We then wadded up balls of newspaper and crammed them down the barrel," Webber wrote.

On time came Postman Love with the day's delivery. When Love was halfway to the door, Bernie yanked on the lanyard and the barrel shot a

red ball of fire up in the air and then a shower of burning paper rained down. The expression on Love's face, Bernie wrote, was priceless. "He threw up the mailbag in the air and ran backwards, much of the mail scattering on the grass...we went out the front door laughing; the scene had made our day." Bernie caught hell from the Chatham Postmaster Paul Carr, and Love was extremely cautious when approaching the Lifeboat Station from then on, but his wisecracks about the Coast Guard had ended.

In November 1961, Bernie was ordered to Coast Guard Headquarters and assigned to evaluate the newly designed forty-four-foot motor lifeboat in November and December from Chesapeake Bay to Cape May, New Jersey. Powered by two diesel General Motors engines and equipped with all the bells and whistles of the day, the self-righting forty-four-footer carried radar, depth-finding apparatus and several radios. Compared to the CG*36500*, with only one engine, a single radio and no radar, the forty-four-footer was state of the art. After a month of arduous sea trials, Bernie and others with whom he worked on the forty-four-footer suggested a long list of changes for marine engineers. In the meantime, Bernie had returned to Chatham for Christmas where he and Miriam had welcomed their second child, daughter Patricia, several years before.

By April 1962, further testing on the newly modified forty-four-footer was required, and Bernie, then thirty-four, "was to take this vessel on a cruise from Curtis Bay, Maryland, southward as far as Cape Hatteras, then proceed northward on a voyage that would take us to Rockland, Maine, then to Chatham." Bernie stopped at every Coast Guard station along the way during those six weeks, and seamen from each of those stations had a chance to inspect, board and drive the forty-four-footer and offer their opinions on the vessel. Webber filtered their remarks to the marine engineers. Bernie kept the CG*44300* at Chatham for another twelve months for more on-site trials, and knew the forty-four-footer would soon become the new standard in search and rescue vessels. The aging, obsolete fleet of thirty-six-footers was burned, and Bernie wondered what would happen to the CG*36500*.

In late August, 1963, Bernie was transferred to the *Cross Rip* Lightship where this time there was no doubt the new duty station was

a punishment for his deteriorating relationship with Group Commander Wright. Wright may have been old enough to have been Bernie's parent, but he was certainly no father figure. At any rate, the *Cross Rip* was decommissioned in October of that year. Leaving Chatham for the last night left Webber reflective. "I left Chatham a better person after having served this place…to me, the son of a Baptist minister who left home at the age of 16 to serve in the Pacific, Coast Guard service, particularly the years at Chatham, put meaning into my life that has lasted."

After a short stint aboard the *Cross Rip*, Bernie was reassigned to the buoy tender *White Sage* at Woods Hole, and he stayed there until July 1964. Next up was a stint as officer in charge of the Cutter *Point Banks* that was ordered to duty in Vietnam. "The Coast Guard cutter *Point Banks*, skippered by Boston-born Chief Petty Officer Bernard C. Webber, thirty-seven, is among seventeen patrol boats being assigned by the United States to sea duty off South Viet Nam," reported the *Boston Globe* on Friday, April 30, 1965.

The Department of Defense had planned on sending two hundred specially trained Coast Guardsmen to man the eighty-two-foot cutters, primarily used for search and rescue missions, which were capable of extended sea duty, yet drew only about five feet of water. Bernie's family was upset by the military orders.

"Mrs. Webber…said her husband was planning to retire next March after 20 years service," the *Globe* reported. "Reverend Alonzo Webber… the Coast Guardsman's father, said today that his son had already made plans with two other men to operate a marina in Chatham. He said his son had just returned from a two-week trip at sea," the paper added.

After Vietnam, Bernie returned to Woods Hole and was assigned to the buoy tender *Hornbeam*. In truth, Bernie found he was in the midst of a new Coast Guard, one to which he didn't feel he belonged. "The politics of the day divided traditional service philosophy," he noted in his memoir. "The values inbred in me over a twenty-one-year period no longer seemed to apply or have any relation to the new image in the process of being developed by the service." It was time to leave. Bernie retired from the Coast Guard in September 1966 at the age of thirty-eight as a chief warrant officer.

His first post-service job was that of Wellfleet harbormaster. He also reconditioned boats, painted cottages and ran a small but successful charter service out of Rock Harbor. "After leaving the Coast Guard I soon found out old Coast Guard 'heroes' were not highly sought after by the civilian labor market," Webber fretted. After a few years Bernie found work with the National Audubon Society in Maine where he signed on as warden–head boatman at the Todd Wildlife Refuge and an Audubon-run education camp. The Webbers would stay in Maine for four happy years. When Bernie was in his early forties he took a new job at the Hurricane Island Outward Bound School in Maine and stayed in that role for two years.

Around this time, in 1973, Bernie was notified of efforts to restore the CG*36500* he had thought was torched when the new forty-four-footer went on line. Instead, the vessel had been given to the Cape Cod National Seashore Park by the Coast Guard in 1969 and remained outdoors, untended and orphaned, while park officials figured out what to do with the boat. "For me it was as if a long lost friend had returned to my life," Bernie remembered. Reluctantly, Webber was enlisted to help raise funds to refurbish the CG*36500*, stored in a boatyard rapidly decaying until William "Bill" Quinn had launched a restoration effort. "In many ways it was embarrassing, but on the other hand, I was being pressured to help them, otherwise I'd be an ingrate," said Webber. With fanfare the CG*36500* was re-launched at Rock Harbor in June 1982. Today, after Quinn had overseen the vessel, then Pete Kennedy, Richard Ryder of Chatham and Don Summersgill manage the CG*36500*, which is still owned by the Orleans Historical Society.

After leaving Outward Bound in Maine, Bernie continued to work in the marine industry, first for dredging companies, "tow boat companies, salvage companies, even a stint with the U.S. Army Corps of Engineers as a marine construction inspector," recounted Webber. It was during one of these jobs when Bernie met up again with former *Pendleton* sailor Charlie Bridges. As a young man of eighteen Bridges had been inspired by the rescue and would later join the Coast Guard.

After forty-two years at sea, Bernie and his wife, Miriam, retired to Florida. And that's where co-author Webster located Bernie in

late 2001 to discuss reuniting Webber with his CG*36500* shipmates, Richard Livesey, Ervin Maske and Andy Fitzgerald. At first, Webber was extremely hesitant.

"This business of being called a hero is really a life wrecker," he lamented in recent years. Hard feelings on behalf of his peers simmered after the February 1952 rescue, and to a degree this still rankled Bernie. "After the *Pendleton* I still had the rest of my Coast Guard career to finish," recounted Webber. People thought Bernie benefited from the publicity, an accusation that stung for decades. "When they see something that was written…money went into my pocket," he said many had assumed. "Most of the guys I had in charge of me resented me…a very difficult career," Webber remembered. "I felt much animosity after '52 for the remainder of my career until retirement in 1966, coming from both enlisted and officers," he said.

It took some doing but Bernie was finally convinced to come to Boston in May 2002 for a fiftieth-anniversary reunion of the *36500* crew and to visit Station Chatham. Not until the Coast Guard reunion in 2002 had Ervin, Richard, Andy and Bernie gathered. And when they met up, it would be another defining moment for the crew.

Chapter 7

MAY 2002

For three days rain drenched the North End, leaving Boston's Little Italy sopping wet. Showers spilled from slate roofs into centuries-old cobblestone streets where walking without an umbrella proved senseless. At night, the splash of rain on rooftops and drops against window panes played a consistent melody of few notes. When morning came, and through the day, not even a sprig of sunlight filtered between aging red brick apartment buildings or glass-fronted shops and restaurants that meandered into mysterious alleys and intersecting side streets. Everywhere a gray pallor repainted narrow blocks and streets.

The North End is a mix of old buildings and structures retrofitted with modern amenities. This area is wedged between Government Center and the Financial District and Boston Harbor; it is a huge tourist draw, home to the Old North Church, the Freedom Trail and other famous sites from the American Revolution. People mix easily here. The North End is still that quintessential tightly knit community: the kind of neighborhood where both young and old walk with no fear and with little crime around. Everyone seems to know everyone else.

Look anywhere and you'll see an Italian restaurant, more per capita than nearly anywhere else in the United States and indeed, some of the finest in the country. Tourists along the main drag, Hanover Street,

politely pass slower-walking residents, many of whom are elderly Italian women who wear their coats buttoned to their chins in warm May.

Coast Guard District One Headquarters on Atlantic Avenue is in the North End, lending the North End a larger purpose than feeding pasta to tourists.

Here in this bustling, historic quarter of Boston, off North Street, is tiny North Square, divided by distinctive and thick black-lacquered chain-link fencing leftover from a huge ship that once sailed into port here. Sacred Heart, a Roman Catholic Italian Church and the adjacent St. John School where Italian is spoken as fluently and effortlessly as English is in North Square too, with no fewer than five Italian restaurants within a stone's throw. This is, after all, Boston's Little Italy.

And next to the Paul Revere House and Museum is the unassuming Mariners' House, a private hotel constructed in 1847 by former fisherman-turned-preacher Father Edward Thomson Tailor "for the sole purpose of providing hospitality and guidance for seafarers," explained Executive Director Michael Cicalese, a longtime Coast Guard officer now serving as a captain in the Reserves.

Inside are two large parlors that resemble what you would find in a Boston mansion one hundred years ago, with ample reading and gathering spaces. A large kitchen with cafeteria space and a business office are on the first floor where in 2010 a guest can buy a hot lunch for three dollars.

Inside it is spotless, beautiful and a convenient locale to stay if Mariners' House was open to the public. Its mission serves seamen only. Those who stay here have to show a merchant mariner's license or have something to do with maritime industries to rate a bed. In any case, it was here that the Coast Guard, led by the initiative of co-author Captain W. Russell Webster who was chief of operations at Coast Guard District One, began its May 2002 reunion of the four crewmembers of the CG*36500*.

The reunion began on the red-tiled floor in front of the reception desk where everyone gathered to meet before dinner. There four stoic men in their august years nervously shuffled their feet and stared at one another uneasily on the red-tiled floor. They barely spoke to one another. A fifth, Charles W. Bridges, stood nearby. "We were virtually strangers," one of the men later said. Decades had passed since the last time Bernie Webber,

Andy Fitzgerald, Ervin Maske and Richard Livesey were together, so the awkwardness was unsurprising.

Finally the years melted and the awkwardness faded. "Oh, Ervin," was all Bernie could say, his deep baritone of a voice cracking with emotion, when he walked forward to embrace Ervin Maske, whom he hadn't seen in fifty years. Ervin, who could barely stand following a recent operation to replace bad knees, entered into a large bear hug with Bernie. "It feels pretty good to see them again," remembered Ervin. "It was worth the trip to come."

"He's the same Andy," Bernie would say later of Fitzgerald. "He hasn't changed one iota. He has a way about him that is as steady as can be. The only difference is his white head of hair."

Surrounding the small circle at Mariners' House was a larger sphere of family—wives, sons, daughters, grandchildren and assorted in-laws—who had accompanied the Gold Medal Crew to Boston, their way paid for by the Coast Guard. Within minutes the old shipmates and their families left Mariners' House for dinner (hosted by co-author Webster) beneath a small fleet of umbrellas along the cobblestone streets in the North End.

Charles W. Bridges had made the trip from Florida. Charlie was a young man of eighteen and a sailor aboard the 503-foot, 10,000-ton *Pendleton* the night the storm cracked the vessel in two. Charles was keen on the trip. Although his initial connection to the Coast Guard was that of being rescued, after a two-year army stint, Bridges enlisted in the Coast Guard in 1955 and retired in 1977 as a senior chief engineer. For the 2002 reunion Charlie had brought his wife, Suellen, now deceased; daughter, Lorraine; and sister-in-law, Lilda, to Boston for the reunion. "It was great seeing the guys," he said from his twenty-acre farm in North Palm Beach, Florida.

Bernie himself had sporadic contact with a few crewmembers over the years. Richard Livesey had phoned Bernie in Florida and visited him there once. Bernie and Andy had exchanged a Christmas card or two. The *Pendleton* mission, however, was something "none of us from the day of the *Pendleton* discussed any part of it." Over the years much was written—some true, some not so true—about the *Pendleton* sinking and the story about the CG*36500*.

Within the world outside Coast Guard circles Bernie had been burned numerous times either through misquotes or negative dealings with people with a personal or financial stake in the story and was understandably leery about talking to anyone about the incident. More than a few people tried to make money off Bernie's story. Still, Webber showed up in Boston to support the 2002 reunion because it was a Coast Guard event, and his comfort level within those circles was high, and—plus—Webber could keep an eye on the other crewmen. Bernie drew support from their presence, too.

"I could relate to how it was fifty years previous with everybody pulling at you, tugging at you, quoting you, misquoting you, pushed here, pushed there, I didn't like it back then, and I know they didn't, and I didn't want to see a repeat of that. I thought the reunion should be a happy time, a time to do away with all the necessities of what reporters wanted to write. I didn't know all the people who were there…so you know you want to see they're taken care of, they're treated right," he would say following the reunion. "I was a career Coast Guardsmen, and I had known Fitzgerald and Maske had gotten out and weren't too up-to-date on how the Coast Guard deals with people, and I didn't want to see them caught up with things which made them uncomfortable," said Webber. Therefore, five decades after their near-death at sea, Bernie's group was together again at the Mariners' House in Boston's North End.

"It was special to have the crew of the *36500* at Mariners' House because it was built for merchant marine personnel, and what better way to show support and gratitude to those men who risked their lives to save—and did save—merchant mariners, than to have them under the merchant marine landmark roof," Cicalese lamented.

The Gold Medal Crew felt the same way about Mariners' House. The second night of the reunion, Ervin opted to dine in Monday evening even though the Coast Guard would have picked up the tab at a restaurant. He wanted nothing more than to enjoy a simple meal in a beautiful place and to rest his throbbing knees, so recently operated on. Bernie, slightly skeptical of the reunion at first, brought his reservations to Boston. Webber had no idea how this latest *Pendleton* event would come off, but he hoped for the best. Clearly, he felt protective about his men even though

Andy, Ervin and Richard had long since left his command. "I was 'still in charge,' and it's a funny thing, you're the coxswain of the boat, you're the captain of it, it's a natural thing, I don't know how they felt, but it was up to me to see they were taken care of," he said later. And Bernie, too, thoroughly enjoyed being at Mariners' House.

For three of the Gold Medal crew, Ervin, Andy and Richard, it would be several days to remember. Bernie dreaded the ceremonies planned for the days ahead and all the fuss and angst he figured he was about to shoulder again. Would this be reminiscent of the 1950s, when the Coast Guard paraded Webber on public relations junket after junket, or had things changed enough for a less troubled series of events? The answer would be an emphatic no, to Webber's relief. The next day, Monday, the *CG36500* crew attended a Luncheon to Honor Heroes, arranged by co-author Captain Webster at the Coast Guard base in Boston. It not only was a huge event, but also a huge success.

Bernie was not disappointed. An oil portrait entitled *Pendleton Rescue* by Robert Selby was unveiled. Rear Admiral Vivian Crea and Congressman

Bernard C. Webber and Captain W. Russell Webster in Boston in May 2002. *Courtesy of Theresa M. Barbo.*

William Delahunt, himself a Coast Guard veteran, were the honored guests. In prepared remarks, Admiral Crea reaffirmed the significance of that one mission in February 1952 and said she was thrilled to meet each Gold Medal crewman. "This is the stuff of which legends are made…it is the stuff that is the basic foundation of the Coast Guard, which motivates the heroes amongst us even today." As the Coast Guard had done half a century before, Admiral Crea and Congressman Delahunt presented Bernie and his crew with reissued lifesaving medal award certificates signed by then 2002 Coast Guard commandant Admiral James M. Loy. Bernie listened to the speeches and watched the faces of the many Coast Guard guests who had come to honor the *36500* crew and was indeed thrilled he had participated in the event.

Ever so slightly, it appeared, the tide of resentment began to recede for Bernie, who felt that for the first time in fifty years the Coast Guard had recognized the entire crew for doing their jobs and had not singled out Webber as a hero. After lunch, the Gold Medal crew relaxed in Boston before leaving for the Cape the next morning, bound for Chatham and

From left: Charles Bridges, Gloria Fitzgerald, Andy Fitzgerald, Virginia Livesey, Richard Livesey, Ervin Maske and Miriam and Bernie Webber. *Courtesy of Theresa M. Barbo.*

further reunion activities. A dinner in the Village Room at the Chatham Wayside Inn was planned for Tuesday evening. If the Boston luncheon at the Coast Guard base was formal, dinner Tuesday evening was a mix of special guests, former and current Coast Guard officers and noncommissioned officers who traded stories and goodwill with the Gold Medal crew and their families. Bernie's face said it all: he was sharing the evening and his memories with his wife, Miriam; their daughter Patricia and her husband, Bruce; and their daughters Leah and Hilary. This was a different Coast Guard than the one young Webber joined after his rebellious teen years.

Vibrant sapphire skies and intermittent clouds on May 14, 2002, over the Lower Cape belied the arctic-like cold. The weather resembled an unfriendly February day rather than the month flowers bloomed with abandon on Cape Cod. But Station Chatham laid out the warmest of welcomes for its former crew when Bernie, Andy, Ervin and Richard, along with Charles Bridges, came to call during the final leg of the Coast Guard reunion.

That morning at the Chatham Wayside Inn, Bernie and Andy caught up over a breakfast of scrambled eggs, toast and bacon. The two discussed how Bernie put together the four-man crew the afternoon of February 18, 1952. "Well, let's put it this way, Andy, there was a lot of guys left on that station that hadn't even been out all day long. You were still in view and available; where was everybody else?" To this day, exactly where other crewmen from the Chatham Lifeboat Station were remains a topic among Coast Guardsmen.

Following breakfast the Gold Medal Crew and their families were loaded aboard Coast Guard vans for the memorial ride aboard the restored CG*36500* at Chatham's famed fish pier. Junior Coast Guardsmen measured and buckled Bernie, Andy, Ervin and Richard into regulation orange jackets. Charles Bridges was not aboard.

Off they went, albeit, awkwardly. Bernie recounted,

To be perfectly honest, I hadn't had a chance to talk with Ervin, Andy, Richard or Charlie. People who plan these events don't realize it's a swirl of activities and those in the spotlight are overwhelmed by events. Little

Andy Fitzgerald, Senior Chief Steve Lutjen of Coast Guard Station Chatham, Ervin Maske, Richard Livesey and Bernie Webber stand at Chatham's Fish Pier before boarding the CG*36500* in May 2002. *Courtesy of Theresa M. Barbo.*

Led by Master Chief Jack Downey, the Gold Medal Crew boards the restored CG*36500* for a reunion cruise at Chatham's Fish Pier in May 2002. *Courtesy of Theresa M. Barbo.*

thought goes into realizing these guys haven't been together or seen each
other for more than fifty years. It was an awkward situation. Inasmuch
we were not a boat crew, but were guests aboard 36500 *for a photo op.*

It was a long day.

In June 2008, Bernie remembered the 2002 event fondly, but it proved exhausting and didn't wholly put Webber at ease. "We had no time together really as we were like cattle shoved about for photo ops and other details. For me it was much like 1952. Those organizing such events do not have the feel what it's like to be on the receiving end, never [having] been in that position."

In truth, there were blocks of rest time built into the reunion over the course of several days, but Bernie was correct that the hours rushed by in a whirlwind with little time to rest. A highlight for Webber was taking command of the *36500* during a cruise near Chatham's fish pier.

As he had done on February 18, 1952, Bernie took the tiller, and that "seemed perfectly normal," he remembered. Over the course of the years since the 2002 reunion, Bernie commented frequently on the reunion, especially the cruise aboard the *36500*. Master Chief John "Jack" Downey, now retired, along with Senior Chief Sheila Lucey, also now retired but then officer in charge of Brant Point Station on Nantucket tagged along in case the CG*36500* crew needed a helping hand. "I got the impression those in charge had preplanned that I not be allowed to bring the boat into the fish pier," Bernie said in January 2007. "I assume the thinking was that the old man was rusty and it best to be on the safe side to let another take over," but he did well that day. Downey and Lucey have since retired from the Coast Guard. Lucey does not remember much conversation, but the poignancy of the moment was not lost on anyone underway on the CG*36500*. "It was awesome to see and watch him handle the boat that he saved so many lives with," remembered Lucey, who called Bernie's presence a privilege. A luncheon at Station Chatham followed in the very room where Bernie scrounged for a doughnut and coffee some fifty years before.

The Gold Medal Crew gathered around a quintessential sheet cake and posed for pictures. After lunch, the official Cape ceremony began

Coast Guard Station Chatham welcomed back its CG*36500* crew in May 2002. Cutting the cake were, from left: Andy Fitzgerald, Richard Livesey, *Pendleton* seaman Charles Bridges, Bernie Webber and Ervin Maske. *Courtesy of Theresa M. Barbo.*

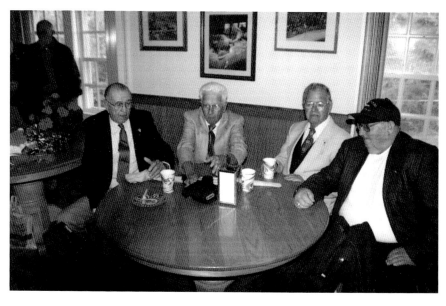

Bernie, Andy, Richard and Ervin take a break during the May 2002 reunion at Coast Guard Station Chatham. *Courtesy of Theresa M. Barbo.*

with the National Anthem sung by a local North Chatham favorite, Carole Maloof.

As the youngest of the four Gold Medal honorees, Andy Fitzgerald was given the duty of unveiling a bronze plaque in honor of the *36500* crew that day in 2002. Among the local dignitaries present were Selectman Douglas Ann Bohman and Parker Wiseman, who would pass on several years later.

The First Coast Guard District chaplain, Lieutenant Commander T.A. Yuille of the U.S. Navy, delivered the invocation. Giving remarks were Captain James Murray, commander of Coast Guard Group Woods Hole, and Captain Webster, co-author of this book, who recognized that Station Chatham remains an indelible element to the town. "We also celebrate a uniquely positive relationship between the Coast Guard and the town of Chatham and other surrounding communities; a town and communities that have embraced their rich maritime past and their Coast Guard," said Webster.

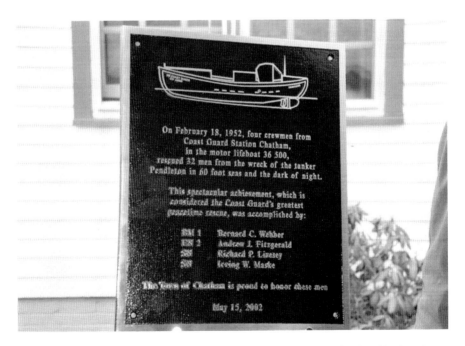

A plaque honoring the *CG36500* crew was unveiled at Coast Guard Station Chatham in May 2002. *Courtesy of Theresa M. Barbo.*

After the speeches, when the sheet cake was polished off, the dishes cleared and most civilian guests gone, a special event for Bernie took place. It was an opportunity for the enlisted men and women to ask Bernie questions about the rescue and the Coast Guard in general without their superiors present. In doing so, several generational gaps were closed, for Bernie was old enough to be grandfather and even great-grandfather to some of the young men and women nearby.

Jason Holm, a recent officer in charge of Station Provincetown, was in 2002 at Station Chatham and present when Bernie spoke to the gathered enlisted and remembered being awestruck. "As a young surfman, I could not wait to meet Bernie and the crew. I could not get over the fact that the crew was back together again fifty years later. Coming out of the meeting that day, I remember thinking how different times were back then, but ironically they dealt with the same issues we still deal with in the Coast Guard today. Bernie and the entire crew were humble and gracious and answered all of our questions. I can only speak for myself, but it was one of the highlights of my Coast Guard career," remembered Holm in the summer of 2008. Holm said the best memory of the day was when "I gave Bernie my surfman pin, he smiled, thanked me and put it on."

This was a slot in the schedule that did not appear on the official program. It was Bernie's wish to speak directly to the enlisted men and women at Station Chatham without officers present. What was said behind closed doors is not talked about today. During Bernie's private time with enlisted folks the captains killed time in the station. Miriam Webber and Captain Murray, then Group Woods Hole commander, would speak at length in Senior Chief Steve Lutjen's office with no one for company except Zoe, the station's chocolate Labrador retriever mascot.

In the late afternoon, co-author Captain Webster, Captain Murray, the Gold Medal Crew and Charles Bridges drove to the headquarters of the Orleans Historical Society for a ceremony to recognize the organization's work in restoring the *CG36500*. They also viewed an exhibit depicting Coast Guard history assembled by Donna and Bob Weber, a retired Coast Guard Reserve Commander who served at Station Chatham and both were instrumental, along with Bonnie and Stanley Snow of Orleans, in organizing the Chatham leg of the 2002 reunion.

A tired but happy Bernie Webber left Coast Guard Station Chatham when the reunion ended in May 2002. *Courtesy of Theresa M. Barbo.*

The Gold Medal Crew returned to Chatham Wayside Inn with their families to pack for home.

A white Coast Guard Dodge van waited to bring the *CG36500* Gold Medal Crew to Boston for flights home or to stay on in Boston an extra night: Andy Fitzgerald and his wife, Gloria, to Colorado; the Liveseys to Florida; Ervin Maske, with his daughter, Anita, and son, Matt, to Wisconsin; and Charles Bridges and his wife, Suellen, and daughter and sister-in-law, to Florida.

Bernie and Miriam would stay on at Miriam's sister's home in Eastham, which Bernie helped build decades ago. Bernie needed to relax and rest.

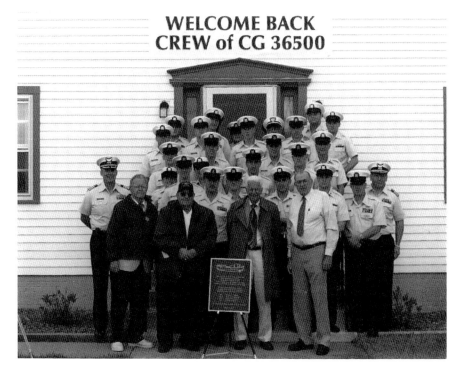

The *CG36500* Gold Medal Crew outside Coast Guard Station Chatham, formerly the Chatham Lifeboat Station, with the crew who served there in May 2002. *Courtesy of Theresa M. Barbo.*

Ervin's daughter, Anita Maske Jevne, said her father loved seeing everyone again after fifty years. Anita never heard Ervin talk of the February 18, 1952 rescue. Once, when she was little, Ervin showed her his medal and explained that "I got this medal from a rescue I did…I saved some men." Until the Heroes Luncheon in Boston that Monday, Anita had not heard the full story. Ervin—quiet, shy, unassuming Ervin— sat alone in the back of the Coast Guard van that afternoon waiting on his son, Matt, and daughter, Anita, who gathered their things for the ride to Boston. His knees ached from a recent double knee replacement operation, so after standing much of several days, Ervin relished quiet time and being able to sit. Ervin appeared OK, just tuckered out. He seemed, however, full of thought, and a quiet that is reflective of his gentle soul. He spoke with co-author Theresa Barbo. "Ya know, the guys in the garage where I worked in Wisconsin didn't believe me when I said

I was on this Coast Guard mission. Now maybe they will believe me." Clearly the May 2002 reunion was a public validation for Ervin.

Two thousand and two marked the last time the Gold Medal Crew would gather. Ervin Maske died on October 7, 2003, near his hometown of Marinette, Wisconsin, after suffering an apparent heart attack at the wheel of a moving, empty school bus.

"The Honor Guard came, and there was a gun salute," Ervin's daughter, Anita Jevne, remembered, speaking by phone from her home in Eau Claire, Wisconsin. "They gave me the flag and inside were three shells from the gun salute." Anita kept one and gave two to her brother, Matt, who came for the reunion and shared that special time with their father. "The man who handed me the flag…he was crying," Anita recounted. "The reason why we are here is because we are taking your Dad's honor with us, so it will always be alive," a young Coast Guardsman explained to Anita.

He was the first of the *CG36500* Gold Medal Crew to pass on. Only Andy is still living, as is Charles Bridges.

Richard Livesey died on December 27, 2007, in Englewood, Florida, after a long illness. He was seventy-seven. He is survived by his wife, Virginia, and six children and several grandchildren from earlier marriages. Richard and Virginia had no children together. Bernie attended Richard's funeral service. In a fitting tribute to his heroism, approximately eighteen to twenty chiefs, senior chiefs and master chief petty officers from the Coast Guard attended. Senior Chief David Considine, a past Officer-in-Charge of Coast Guard Station Chatham, made the trip to Florida to pick up Bernie at his Melbourne, Florida home, and accompany him to the National Cemetery in Bushnell for Richard Livesey's internment on February 19.

A full Coast Guard Honor Guard presented the national ensign to his widow. A drummer and bagpiper from the Coast Guard Pipe and Drum band played *Amazing Grace*, and a trumpeter played *Taps*. To note how strong ties were between these former Coast Guardsmen who had been involved in various aspects of the rescue, Bernie was pleased to see Mahlon Chase of Dennis, Massachusetts, at Richard's service, held at the Military Cemetery in Bushnell.

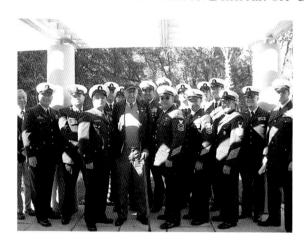

CG*36500* Coxswain Bernie Webber is surrounded by chiefs at Richard Livesey's funeral in February 2008. *Courtesy of Bernard C. Webber.*

Master Chief Chuck Winter read "Crossing the Bar" by Alfred, Lord Tennyson, and the traditional farewell at Coast Guard services:

> *Sunset and evening star, And one clear call for me! And may there be no moaning of the bar, When I put out to sea, But such a tide as moving seems asleep, Too full for sound and foam, When that which drew from out the boundless deep Turns again home. Twilight and evening bell, And after that the dark! And may there be no sadness of farewell, When I embark; For tho' from out our bourne of Time and Place The flood may bear me far, I hope to see my Pilot face to face When I have crossed the bar.*

Bernie delivered Richard's eulogy:

> *I first met Richard Livesey around 1950 when he arrived for duty at the Chatham Coast Guard Station on Cape Cod, Massachusetts. Richard was a personable young Coast Guard seaman first class, squared away, full of fun, ready and willing to serve and do anything the service required of him. I was a boatswain mate first class. Richard and I spent many days out to sea together in fog, rain, sleet and snow. In calm seas, and in seas rougher than we could ever have imagined, pursuing Coast Guard duties, answering distress calls from those in peril upon the sea, and in support of other Coast Guard*

operations such as Lightship Logistics, and the maintenance of Aids to Navigation. Richard was never one to complain, no matter how tough the job or how rough the sea. He was one of those rare individuals who was in awe of Mother Nature and would become excited at the prospect of being able to save a human life. He would even get excited during a routine Lightship run in rough weather when the cargo or groceries we carried were safely deposited on board, and the exchange of personnel accomplished without incident. I never understood it, but Richard had a habit of saying, "thanks, Webb," every time we accomplished a mission or finished a job. In time I found that Richard was willing to go far beyond the call of duty. Such was the case fifty-six years ago yesterday. The occasion: two T-2 type Tank Ships—the Fort Mercer *and* Pendleton—*split in half during a great northeast snow storm out in the Atlantic Ocean off Cape Cod, Massachusetts. The winds blew seventy miles an hour with freezing cold weather and high seas unlike any of us had ever seen before. I was ordered to crew a Coast Guard motor lifeboat, the CG36500, and proceed to the aid of the Pendleton. I needed volunteers for the mission. Immediately from Richard I heard, "I'll go with you, Webb." I also heard from two others: Engineman Andrew Fitzgerald and Seaman Ervin Maske; they also volunteered for the perilous mission. Richard and the others, without regard for their own personal safety, time and time again placed themselves in a life-threatening posture to save the lives of* Pendleton *crewmen, leaning far out over the lifeboat's rail to haul them in, helping them any way he could, into the lifeboat without hanging on, until thirty-two of the thirty-three crewmen from the tanker* Pendleton *were onboard the overcrowded, heavily laden, motor lifeboat. Once the mission was over, and the survivors safely in the warmth of the Chatham Coast Guard Station, or had been taken to a hospital, Richard once again turned to me in his usual cheerful manner and said, "Thanks, Webb." I say today, as does the United States Coast Guard, thank you Honorary Chief Richard Livesey. Your service will always be remembered. May you now and forevermore rest in peace. God be with you.*

Mr. Livesey retired as a boatswain's mate first class and was recently awarded the honorary promotion to the rank of chief petty officer by Charles Bowen, the recently retired master chief petty officer of the Coast Guard.

"From my observation having made trips in the last couple of years aboard Coast Guard vessels and visiting shore-stations, any beefs I had about the old days have been resolved," Webber says. "From my perspective it's a great time to be in the service, and I've never been prouder to say I had served in the United States Coast Guard."

The 2002 reunion put Bernie and the *CG36500* crew back into the sights of Coast Guard superiors and those in the service.

BERNIE'S AUGUST YEARS

B ernie kept his hands in Coast Guard doings over the years, staying in touch with old friends, but it was the last decade of his life in which he was reimmersed into an official engagement with the service.

Artist Tony Falcone of Prospect, Connecticut, was commissioned to paint a series of paintings about the history of the United States Coast Guard, and was assigned a "Champion" to "get it right" since the Coast Guard was a new world to Falcone. Today the mural hangs at the Coast Guard Academy in New London, Connecticut. Bernie was Tony's Champion for the painting, called *36500 Rescues the MV Pendleton, 1952*. "Not only did he know every detail of the events surrounding this incredible rescue mission, but he was the person on the scene… to say that he brought this historic event to life is an understatement," Falcone remembered.

"Working together meant that we discussed all aspects of Bernie's heroic struggle to make it to the tanker, rescuing the crewmen from both the tanker and his own vessel, one after another, and making it safely to shore." Bernie and Tony exchanged sketches, and Tony recounted they went over each one, including every angle and aspect, and "how Bernie endured my endless questions, I will never know." Falcone commented that their collaboration enabled Bernie to revisit the rescue. "After

working with him, I am able to understand how a man of his character could accomplish what he did. He is truly a unique man."

Following the 2002 reunion, Bernie visited with Senior Chief Sheila Lucey at the Station Brant Point. "He came out and ran the forty-seven-footer, and that was way cool watching him handle the new platform," Lucey remembered. Bernie watched their drills and performed a few of his own, to rave reviews of Lucey's crew. "He made it all about them… talked about how impressed he was with their skill…the crew couldn't have been higher." Bernie handed the boat crew and coxswain certificates for some newly qualified members. "They couldn't believe it," Lucey recounted. "They were humbled by his presence…he has an ability to make these guys feels like they are the heroes, and what an awesome gift that is to give to a young guy just starting out."

Sheila has since retired from the Coast Guard and is assistant harbormaster of Nantucket.

In Melbourne, Florida, neighbors knew nothing of his Coast Guard career and the CG36500, and Bernie liked it that way. Once in a while, Bernie would take a pot of his famous Bernie's Beans to the rec hall for cookouts, where he resided, "once in a while and I don't know anyone there." He was just one more devoted but retired Coastie.

In retirement Bernie became something he'd only dreamt about his entire adulthood: a writer. Not only did Webber pen *Chatham, the Lifeboatmen* in 1985, he also composed *Lightships Remembered, One Man's Experience with History*, in 2002. The latter work remains unpublished. Meticulously researched, this university-grade manuscript clearly reveals Bernie's depth of knowledge of Lightships. He once told co-author Theresa Barbo that "I wished I had gone to college," as he relished the thought of becoming an author. He loved to write.

Bernie's retirement years were filled with activities he enjoyed. Never did he discuss his Coast Guard heroics. And it wasn't until after he died, when a local newspaper ran a story about Bernie that his friends knew anything about the unassuming Bernie. Miriam says he was never one to brag.

Still, the aftermath years—and there were decades of them—were anything but easy for Webber. "I am so sick and tired myself about

hearing about Bernie Webber. I've put up with so much animosity," the former coxswain said, adding, "it really stinks."

"After the *Pendleton* I still had the rest of my Coast Guard career to finish. It caused a lot of animosity for people in the Coast Guard," Bernie once shared. Each time he was interviewed, which was quite a few times, the guys with whom Bernie served thought Webber was paid to give remarks when in fact he was not. "It was a very difficult career."

Haunting Bernie up until his death, however, was a conversation he heard about only a few years ago when retired chief bosun mate Ralph O. Morris, now in his mid-seventies, visited Bernie and Miriam in Florida. Morris worked for Bernie while Webber ran the Race Point Station in Provincetown in 1955.

Morris told Webber of a chance encounter in Hyannis in 1953 with the widow and young son of Tiny Myers, the ordinary seaman aboard the *Pendleton* who perished during the rescue effort. The three met up in front of Puritan Clothing store when Morris dashed in to buy some civilian clothing. Coming out of the store, the Myers lad stared at the Coast Guard uniform Morris wore. Morris said the child looked to be between eight and twelve.

"Are you in the Coast Guard?"

"Yes, I'm in the Coast Guard," Morris replied.

"Do you know Bernie Webber?"

"I don't know him, but I know of him," Morris told the boy.

Morris, just a year or so out of boot camp, had heard about Bernie's story during his training but had failed to connect the dots about which the Myers child was talking.

Morris and Webber would not meet until several years later.

"He says to me, 'He killed my father.' I didn't know at the moment, he caught me by complete surprise and shock because I had no idea who he was, where he came from, and I didn't know what story he was talking about," Morris said from his home in Texas.

Morris asked the boy how Bernie had killed his father.

Mrs. Myers then stepped in and replied for her son. "His father got caught between the ship and the lifeboat when he was rescuing the people off the *Pendleton*." Morris said he leaned over the fatherless boy and "I

told the kid, 'Let me tell you something: you gotta remember there were two ships that broke up that night, and the *Pendleton* was one of them.

When you're trying to rescue people in weather that would break up two ships it is almost impossible to blame anybody for losing anyone.'" Morris called the loss of Tiny "an act of God for not the fault of any one person."

Morris remains adamant that "it's a miracle they even got out of Chatham" that night. The belief that Tiny Myers's son would have thought Bernie was guilty of taking his father's life wore on Webber like a thick chain around his heart. That was Bernie: tough as nails, but deeply sensitive. The loss of Tiny Myers affected every crewman aboard the *36500*—Livesey, Fitzgerald and Maske. In private moments at the *Pendleton* reunion in Boston in May 2002, each spoke of Tiny as if the loss was a fresh wound, rather than George Myers having died over fifty years ago. Even after fifty years, the crew of the *36500* remembered still the one they could not save, although they carried thirty-two others to safety. They have seen Tiny's face in their minds through the years as he

Bernard Webber's ashes are carried during his funeral service on Cape Cod in May 2009. *Courtesy of the U.S. Coast Guard.*

reached through the freezing seas for their hands. Seeing a good man die under tragic circumstances never leaves a would-be rescuer's memory.

Years ago Miriam and Bernie planned to be buried on Cape Cod near Miriam's hometown of Wellfleet. Miriam is a Pentinen, and her people are buried at the Wellfleet Pleasant Hill Cemetery. The funeral was May 9, 2009, at the Wellfleet United Methodist Church, the day Bernie would have turned eighty-one.

In a twist of fateful irony, ceremonies were held the day before, on Friday, May 8, at Coast Guard Station Chatham to decommission the forty-four-foot motor lifeboat, renowned for its self-righting steel hull, a vessel for which Bernie was instrumental in testing and evaluating in the 1960s.

Half of Bernie's ashes were strewn over the bar from the decks of the *CG36500*, and half were interred at Pleasant Hill Cemetery. Bernie had spent over forty years at sea, first as a teenager in the merchant marine, in the Coast Guard from 1944 to 1966, then in various marine-related jobs including Wellfleet harbormaster. It was his service in the Coast Guard and that one particular night in '52, for which Bernie is lauded.

The *CG44301* was formally retired offshore from Coast Guard Station Chatham on May 8, 2009. During his Coast Guard career, Bernie Webber helped conduct sea trials of the prototype of the vessel. *Courtesy of the U.S. Coast Guard.*

Bernie's friends on Cape Cod took the news of his passing hard and wore their heartbreaks on sleeves.

One of Bernie's closest friends was William "Bill" Collette, a former lightship Coastie and current director of the Coast Guard Heritage Museum at the Trayser on Route 6A in Barnstable. Few knew how close Webber was to Collette, who proved a stabilizing force in the early days when the museum was finding its sea legs. Some of Webber's memorabilia remains safely displayed in the Barnstable museum including one of Bernie's enlisted uniforms. Bernie's advice and support encouraged Collette. That's a side to Bernie his close friends knew: his business acumen was staggering. Webber's knowledge of marketing and finding niches and building bridges and relationships were his forte. "Bernie was a hard taskmaster but a great champion for his men. He was a born leader," Collette said.

 Bernie's old Coast Guard friend Daniel Howes "Dan" Davidson Jr., who became a minister and would preside over Bernie's funeral services, was devastated by his death. Davidson had worked with Bernie on the sea trials for the forty-four-footer in the 1960's. Born and bred on Cape Cod, Davidson joined the Coast Guard at seventeen, in the mid-1950s, and his first duty station was the *Cross Rip* Light Station in Vineyard Sound. Davidson briefly had served aboard the *White Sage*, a 101-foot buoy tender based in Woods Hole. But it was at Station Chatham on Cape Cod's elbow during a six-year stint where Davidson had met Bernie, whom he calls a "very talented chief boatswain's mate, mentor and a great friend." Davidson was awarded a silver medal from the Humane Society of the Commonwealth of Massachusetts for his bravery; skill and lifesaving work in saving the lives of seven men during the last breech's buoy rescue on Cape Cod: the 1962 shipwreck the F/V *Margaret Rose*.

The two had spent many hours together test cruising the forty-four-footer.

Bernie was progressive and saw the advancement of women in the Coast Guard as a great move. He was particularly fond of Senior Chief Sheila Lucey, then officer in charge of Station Brant Point on Nantucket where he visited Lucey several times:

Every time Mr. Webber visited the Station, he would tell the story of the rescue once and answer questions from the crew for a short period afterwards. He would then spend the rest of the time asking the guys about themselves, their careers, their "greatest moments" and their greatest challenges. He made us feel important and that we were the "heroes." It was an awesome thing to see a young Coast Guardsman, watching and listening to a true hero and then see the pride on their face when Mr. Webber told them how impressed he was with them and "their" Coast Guard. He got underway with us and watched us do drills. After each drill, he would pat the coxswain on the back and say great job (if it was a great job).

When it wasn't he would tell them to "try again" cause he "knew they could do better." When he ran the boat and we tried to tell him great job, he would tell the crew that "they got him through it." What a gift to a newly qualified Boat Crewman. His presence and encouragement inspired and motivated each one of us to do our best and strive for excellence. He came and visited us in the summer, and wrote to us in the winter. He celebrated our accomplishments and encouraged us when we needed a boost. It was an honor and a privilege to have him as our friend and mentor and we will miss him forever. He touched our entire crew and I have heard from several of them since last week and all have expressed their sadness and sense of loss. He was just a great guy and he left his mark on at least 32 people from Brant Point Station.

Four days before Bernie died, in an e-mail to the authors dated January 20, 2009, Bernie reflected on the rescue that remained embedded in his mind. "In other words my successes at sea in large part were due to my Maritime Service Training (which was a lot tougher than the Coast Guard training and I'm one of them merchant mariners)."

In the hours following Webber's funeral services, an idea was borne that would ensure Bernie's memory in a tangible way and keep it alive, and that of the famous CG*36500* rescue, for generations. And it was cooked up on a plane en route to Washington, D.C., from Cape Cod Air National Guard Base following Bernie's funeral services, by the highest ranking

senior officer in the Coast Guard, Commandant Admiral Thad Allen, who sat with the highest ranking enlisted officer, Master Chief Petty Officer Charles "Skip" Bowen, in the Coast Guard. (Both men have since retired.)

In March, then commandant Allen decided to name the new class of cutters after enlisted heroes. Naming the cutters in the Sentinel class after Coast Guard heroes from the enlisted ranks will keep the focus on some of the significant people who influenced the service, and who were not senior officers or commandants, explained Bowen and Smith, the recently retired master chief of the Coast Guard Reserves.

Admiral Allen decided right then and there, on May 9, 2009, on that Coast Guard plane ride back from Cape Cod, that the first-ever 154-foot Sentinel class cutter would be christened the *Bernard C. Webber*. Admiral Allen said Bernie deserved this honor because, Bowen added, Webber "embodied so much of that Guardian Ethos and was representative of that ethos and arguably the service's greatest rescue." The new cutter class is called the Sentinel, an entirely new class of cutter of 154-footers, destined to take the place of the near-obsolete 110-foot coastal cutter. According to Bowen and Master Chief Petty Officer of the Coast Guard (Reserve) Jeffrey Smith, "The 154' cutters have larger crews, longer sea legs (endurance), and can operate in higher sea states than their predecessor Island Class cutters." A stern-launch boat like the 87' cutters will enable crews to expand their rescue capability.

"We both talked about the Coast Guard needing a cutter class that linked us to our immediate past," Bowen offered through an e-mail interview. "The timing was such that we had recently rolled out several heritage focused initiatives such as our service-wide ethos, the Guardian Ethos. We were looking for ways to emphasize our service history," he clarified. "It's interesting how Bernie helped transition the Coast Guard from the historic *36500* rescue craft he used during the 1952 rescue as an active participant with the on boarding of the 44-foot motor life boats, and his with fifty-eight year dialogue with Coast Guardsmen," insisted Bowen and Smith, both of whom had recently retired.

The keel laying ceremony for the 154-foot patrol boat, *Bernard C. Webber*, took place on April 9, 2010, at Bollinger Shipyards in Lockport, Louisiana, before an audience of hundreds. Louisiana governor Bobby

In April 2010, Bernie's daughter, Mrs. Patricia W. Hamilton, stamps the keel of the *Bernard C. Webber* under construction in Louisiana. *Courtesy of the U.S. Coast Guard.*

Jindal attended, as did Admiral Thad Allen, who was about to retire as commandant. Simply, Bernie would have been floored and exceedingly humbled to know that an $88 million vessel would carry his name, and the initials of his daughter, the sponsor, on its keel.

"This Sentinel class cutter will still be in commission until almost the midpoint of the 21st century, 100 years after Bernie's famous 1952 rescue," recounted Bowen and Smith. "In some ways, like Bernie's self-effacing efforts to remain relevant and connected, the cutter will provide a continuing connection to those Coast Guardsmen who follow in his footsteps for generations to come." Once commissioned sometime in 2011, the *Bernard C. Webber* will call Key West its homeport, though a voyage to Cape Cod waters is expected.

"I am glad I'm still alive, but very sad that my three shipmates are no longer with us," Andy remarked recently in an email with the authors. "I wish Bernie had lived to receive the great honor of having the first Sentinel Class cutter named for him. I also think it honors all of us involved with the rescue." Clearly, up until the hour of his death, and long beyond, Bernie's long life had and will continue to have relevance to the service.

Bernie cherished loved ones and friendships over money or material goods. He was a diligent correspondent who prided himself on staying in touch with his Coast Guard friends. Before his death, Webber and his wife, Miriam, discussed moving back to Cape Cod to be with "his old Coast Guard buddies." In truth, his friendships lasted his lifetime and Webber stayed current on Coast Guard policies and happenings.

Bernie, ever old-school about discretion, would only respond when asked was there anything else about the *Pendleton* rescue these authors should know. "True friendships are things that don't deal in the *Pendleton*," he added.

"There are many skeletons left in the closet," remarked Bernie. "I feel it best they remain that way."

Authors' Note:

The day before Bernie died, on January 23, 2009, in the early evening, Webber sent an e-mail to authors Theresa Barbo and Russ Webster reflecting upon his Gold Medal and the changes the Coast Guard had instituted in awarding the service's highest honor.

Here is the e-mail in its entirety:

"Amazing how one Gold Lifesaving Medal has gotten so much mileage, 57 years later. I'm depressed when I realize Coast Guardsmen no longer can receive the medal

for a deed accomplished while on duty, but only accomplished when off duty. The Congressional Medal of Honor is given for the saving of lives during combat and that's understood. What represents the saving of lives by Coast Guardsmen while on duty today? The Coast Guard Medal? Doesn't sound right, have the meaning, or having the same lasting effect. But, what do I know about the so-called 'improvements' that have taken place over the years. B."

Chapter 9

FOUND HEROES

"GOING FOR THE GOLD: THE USCG'S LIFESAVING MEDALS"

By Captain W. Russell Webster, USCG, (Retired)

Originally published in Wreck & Rescue Journal, *volume 3, number 3*

The Coast Guard recognizes America's heroes for their daring, and often death-defying water rescues with the prestigious Gold and Silver Lifesaving Medals. On average, five or six Gold Lifesaving Medals are given out each year to recognize extraordinary acts of heroism. About fifteen Silver Lifesaving Medals are given out annually for slightly lesser acts of courage.

These medals are like Olympic medals in one sense because they have great meaning to the recipients and those that have been saved. In another way, they are unlike Olympic medals because they recognize a single defining moment in the lives of the participants—a moment that no amount of training could prepare the participants. Some have likened the Lifesaving Medals to the prestigious Medal of Honor in terms of

their rarity and importance. They are a tribute to selfless heroism in the face of death.

The process of investigating these acts, especially those acts that have gone unrecognized for many years, costs time for local Coast Guard commands, but offers unique rewards when the investigation is finally completed. The Gold and Silver Lifesaving Medals were established in 1874 by an act of Congress, which authorized the Secretary of the Treasury to bestow the medals upon individuals who endanger their own lives in saving or endeavoring to save lives from the perils of the sea, within the United States or upon any American vessel. In 1967 this authority was transferred to the secretary of transportation, with administrative oversight being transferred to the commandant of the U.S. Coast Guard.

The Gold Lifesaving Medal, originally designated the "Medal of the First Class," was created for "acts of extreme heroism," while the Silver Lifesaving Medal, designated as "Medal of the Second Class," was for lifesaving acts of a lesser degree of heroism or risk of life. Civilians as well as military members under certain conditions are eligible to receive lifesaving medals. Coast Guardsmen may, under certain circumstances, and with the commandant's approval, receive a 10 percent retirement bonus for having been awarded a lifesaving medal. Examples of Coast Guardsmen who have received this bonus are rare because the lifesaving medals are non-military awards, usually reserved for actions that occur during off-duty times. The medals are among the most valuable, the Gold Medal being composed of 99.9 percent pure gold, and the Silver Medal being composed of 99 percent pure silver. The first Gold Lifesaving Medals were awarded in 1876 to three brothers who saved the survivors of a shipwreck on Lake Erie. The brothers maneuvered their twelve-foot boat in high seas and gale-force winds to reach the victims. The first woman to be awarded the Gold Lifesaving Medal was Ida Lewis, the daughter of the keeper of the Lime Rock Lighthouse in Rhode Island. On February 4, 1881, two soldiers were crossing the ice between the lighthouse and the garrison at Fort Adams when they fell through the weak ice and plunged into the frigid waters below. Miss Lewis, standing on the dangerous ice, threw the survivors a rope and pulled them to safety one at a time. Miss Lewis was known to have rescued at least thirteen

others from drowning prior to this incident and as many as twenty-five throughout her career as a light keeper at Lime Rock Light.

Notable recipients of the awards include Navy Commander Chester W. Nimitz, who received the Silver Lifesaving Medal for rescuing a shipmate off Hampton Roads, Virginia, in 1912, and Navy Lieutenant Richard E. Byrd, who also received the Silver Lifesaving Medal for rescuing a shipmate in Santo Domingo in 1914. There is no statute of limitations for the awarding of the Gold or Silver Lifesaving Medals. Take the Pea Island, North Carolina Lifesaving Station, the only all-African American crew in the U.S. Lifesaving Service (the USCG's predecessor organization). The crew was recognized on October 11, 1996, for its daring rescue of the schooner *E.S. Newman*'s crew on October 11, 1896! Relatives of the seven-man Pea Island crew were on hand to see their descendants receive posthumous recognition for having successfully battled hurricane-force winds and the Atlantic's surging waters to save nine men from the *E.S. Newman*. In a more typical example, the Coast Guard took twelve years to recognize another hero. On the afternoon of July 3, 1984, fisherman Jack Newick rescued Mr. James Sanborn and Mrs. Marjorie Blair from beneath a capsized twenty-seven-foot-long sailing vessel in Little Bay, New Hampshire.

Mrs. Blair and Mr. Sanborn were two of a sailboat's crew of five that had been beset by a sudden sixty-knot squall. The other three lucky crew had been literally ejected from the sailboat as it turned turtle and had been rescued by a cruising USCG Auxiliary craft. Mr. Newick, a Mr. Heaphy and a Mr. Scritchfield heard the distress calls issued by the local marina. Newick and his two friends embarked immediately in their fishing boat and were on scene within minutes of the sailboat capsizing. Despite the sixty-six-degree water temperature in Little Bay, Newick jumped in the water and got on top of the capsized sailboat, where he heard Mrs. Blair's desperate cries for help. Mrs. Blair was pounding urgently on the hull with a fire extinguisher, and Newick felt the vibrations through his feet.

On Newick's first dive eighteen feet beneath the surface, he became entangled in the sailboat's rigging, but still managed to determine there were two survivors under the boat. Newick again dove beneath

the surface and fastened a line to the lower part of the mast. Mrs. Blair later indicated she and Mr. Sanborn shared a pitch-black, claustrophobic air pocket the length and width of two heads! Time was running out. Heaphy then heaved around on the fishing vessel's winch and righted the sail vessel to a forty-five-degree angle, but did not break the air pocket, which the two victims relied upon. Newick then dove two more times through the maze of rigging and sail, without a wet suit or scuba gear, and brought Mr. Sanborn and Mrs. Blair to the surface. Newick was in the frigid water for twenty-five minutes. Mrs. Blair was treated at a nearby hospital and released the day after the rescue.

The seventy-six-year-old Mr. Sanborn, exhausted from his ordeal, was hospitalized in critical condition. Despite Scritchfield's performance of lifesaving CPR on the boat ride to shore, Sanborn had a stroke two days later and died. Mrs. Blair still sends her rescuers a Christmas card each year, thanking them for giving her the gift of life. Jack Newick was awarded the Gold Lifesaving Medal in a ceremony at Base South Portland, Maine, in 1996. Heaphy and Scritchfield were also recognized for their extraordinary efforts and received USCG Public Service Commendations. Recognizing today's and yesterday's heroes is the right thing to do, but can be time consuming, especially as the Coast Guard streamlines itself. While the Coast Guard receives outstanding press coverage when it recognizes old and new acts of courage, that same press coverage routinely brings the promise of one or two new disclosures of unrecognized heroes and heroic acts.

Each disclosure must be researched and investigated, taking typically well over one hundred hours. In the case of older events, where memories have faded and witnesses are not easily located, the time investment is often greater. Many investigators do their research in front of a microfiche reader or sifting through stacks of old papers. Some older events have occurred before the newspapers had converted to computer storage methods. In an environment where the Coast Guard is streamlining, this time investment can be a consideration for the small Search and Rescue units that normally receive these inquiries. However, the USCG must be *semper paratus* (always ready) to recognize its deserving lifesavers lest they sink into oblivion.

THE CG*36500*

A Master Chief's Perspective

Ifirst heard about Bernie Webber and the CG*36500* when I was a second class boatswain's mate in 1968 at Point Judith, Rhode Island. Stories about Bernie filtered down through other people and hearing about the CG*36500* had always intrigued me.

In 1988, I had the honor of finally meeting Bernie while I served as officer in charge of Station Chatham. From then on, I'd see him every year when he visited Cape Cod until I left Chatham in 1993. He'd come to the station every summer and we'd sit on the mess deck and have coffee, sometimes share a meal and reminisce about the boat.

We'd also talk about the Coast Guard; the discussion would always lead to how the Coast Guard did its job. Bernie talked about his Coast Guard, my Coast Guard and today's Coast Guard: the past, the present and the future. His tone was always supportive of the service, and Bernie often remarked how "the equipment gets better and better." Bernie's philosophy was "we have to do better for the next generation." To me, he seemed to be saying to always remember that someone came before you who set you up for success.

Bernie and I would take the CG*36500* for rides. He enjoyed it and occasionally drove it.

Driving the CG*36500* was an honor and privilege but I never took the vessel out in seas greater than four or five feet, but you knew the boat could do much more than that. The CG*36500* was not complicated: it had one engine, one rudder, one throttle, and you couldn't go faster than you could think! When you were on the CG*36500*, the boat would tell you what you could and couldn't do—you could feel the way the boat was handling. We call that sea talk.

In those years the CG*36500* was moored at Stage Harbor. A fellow named Fiske Rollins put up the money to maintain the boat. Fiske was around when the first makeover happened in June 1982, and it needed a bit of TLC every year after that. Fiske was an older man who insisted on checking the moored boat himself by rowing a small dory out to it.

After a while, I didn't think it was a safe thing for Fritz, so that's when we really stepped it up. Boatswain's Mate Sheila Lucey; Boatswain's Mate Tom Guthlien, executive petty officer; and I would haul the CG*36500* to the station and wash, paint and look after it. The three of us were the mainstays for a while. Tom is now commanding officer of Coast Guard Station Castle Hill in Newport, Rhode Island, and is also the Third Ancient Keeper of the Coast Guard. And Sheila retired with her last posting as officer in charge of Station Brant Point on Nantucket. These days, Sheila is assistant harbormaster on Nantucket.

When I left Chatham for Station Brant Point on Nantucket in 1993, I took the CG*36500* there and kept it on Nantucket for one and a half years. We took it to many public events and delivered Santa Claus to Nantucket Boat Basin every year for the beginning of the Nantucket Christmas Stroll.

I credit people like Bernie Webber because the things he did put into play elements of the Coast Guard I was in.

We stand on the shoulders of those who have served before us: the people and their resources. Bernie would agree, for he was straightforward and uncomplicated. For instance, the group of people who developed the now-retired forty-four-footer gave us the techniques we now use in the forty-seven-footer. And those techniques were honed aboard the thirty-six-footer. The marine engineers listened to those driving the boats and perfected each new generation of vessel. Each boat was constructed

according to the experiences and wisdom of past generations of lifesavers. Boats don't do anything without the people who run them.

Bernie lives on in one's heart. I for one was privileged to be considered a shipmate of his, and I am a better person for it. Bernie's performance, humble attitude and good deeds are his legacy—his past and present are gifts for today, to the future of the Coast Guard and to all those Shipmates who serve.

Master Chief John "Jack" Downey, (Ret.)

THE CG*36500*–PENDLETON
LEADERSHIP SERIES

As the chroniclers of Bernie Webber's story—and as his friends—we are proud to have the opportunity to tell his story before diverse audiences in the hopes of enriching, educating and inspiring new generations of leaders.

Our motto is: Timeless Lessons of Yesteryear for Tomorrow's Leaders.

So far we have presented this before several thousand people.

To date, we have traveled to the U.S. Merchant Marine Academy in Kings Point, New York; SUNY Maritime in the Bronx; the Massachusetts Maritime Academy; the Maine Maritime Academy; and the Naval Academy Preparatory School in Newport, Rhode Island. We have, naturally, been to New London, Connecticut, at the Coast Guard Academy and the Academy's Institute for Leadership, with plans to address a ROTC unit at Norwich University in fall 2010.

We have even had the CG*36500* back to the academy and unsuccessfully tried to pack thirty-six lithe cadets onto the venerable craft.

Seeing these cadets and midshipmen, answering their questions and engaging with them in a dialogue about leadership has been extremely rewarding for the three of us.

It's our hope to continue the Leadership Series into the foreseeable future.

Master Chief John "Jack" Downey, (Ret.), addresses cadets at the Coast Guard Academy at the launch of the *CG36500–Pendleton* Leadership Series in April 2009. *Courtesy of Theresa M. Barbo.*

Theresa M. Barbo
Master Chief John "Jack" Downey, (Ret.)
Captain W. Russell Webster, (Ret.)

Appendix:

TOP TEN
COAST GUARD RESCUES

O n August 4, 2007, the Coast Guard released a statement that read, in part: "Washington—The U.S. Coast Guard announced during a ceremony today in Grand Haven, Mich., for its 217th birthday that 1,109,310 lives have been saved since its establishment in 1790."

TOP TEN COAST GUARD RESCUES

Hurricane Katrina

Search and rescue operations alone saved 24,135 lives from imminent danger, usually off the roofs of the victims' homes as flood waters lapped at their feet. Coast Guardsmen "evacuated to safety" 9,409 patients from local hospitals. In total, 33,545 souls were saved. Seventy-six Coast Guard and Coast Guard Auxiliary aircraft took part in the rescues. They flew 1,817 sorties with a total flight time of 4,291.3 hours in the air. The aircrews saved 12,535. A total of 42 cutters and 131 small boats also participated, with their crews rescuing 21,200. Over 5,000 Coast Guardsmen served in Katrina operations.

Prinsendam *Rescue*

A fire broke out on the Dutch cruise vessel *Prinsendam* off Ketchikan, Alaska, on October 4, 1980. The *Prinsendam* was 130 miles from the nearest airstrip. The cruise ship's captain ordered the ship abandoned and the passengers, many elderly, left the ship in the lifeboats. Coast Guard and Canadian helicopters and the cutters *Boutwell*, *Mellon* and *Woodrush* responded in concert with other vessels in the area. The passenger vessel later capsized and sank. The rescue is particularly important because of the distance traveled by the rescuers, the coordination of independent organizations and the fact that all 520 passengers and crew were rescued without loss of life or serious injury.

Pendleton *Rescue*

On February 18, 1952, during a severe nor'easter off the New England coast, the T-2 tankers SS *Fort Mercer* and SS *Pendleton* broke in half. BM1 Bernard C. Webber, coxswain of motor lifeboat CG*36500*, from Station Chatham, Massachusetts, and his crew of three rescued the crew of the stricken tanker *Pendleton*. Webber maneuvered the thirty-six-footer under the *Pendleton*'s stern with expert skill as the tanker's crew, trapped in the stern section, abandoned the remains of their ship on a Jacobs's ladder. One by one, the men jumped into the water and then were pulled into the lifeboat. Webber and his crew saved thirty-three of the thirty-four *Pendleton* crewmen. Webber and his entire crew were awarded the Gold Lifesaving Medal for their heroic actions. In all, U.S. Coast Guard vessels, aircraft and lifeboat stations, working under severe winter conditions, rescued and removed sixty-two persons from the foundering ships or from the water with a loss of only five lives. Five Coast Guardsmen earned the Gold Lifesaving Medal, four earned the Silver Lifesaving Medal and fifteen earned the Coast Guard Commendation Medal.

Dorchester *Rescue*

On February 3, 1943, the torpedoing of the transport *Dorchester* off the coast of Greenland saw cutters *Comanche* and *Escanaba* respond. The frigid water gave the survivors only minutes to live in the cold North Atlantic. With this in mind, the crew of *Escanaba* used a new rescue technique when pulling survivors from the water. This "retriever" technique used swimmers clad in wet suits to swim to victims in the water and secure a line to them so they could be hauled onto the ship. *Escanaba* saved 133 men (one died later) and *Comanche* saved 97.

Joshua James and the Hull, Massachusetts, Life-Saving Station (October 25–26, 1888)

Over the two-day period Keeper Joshua James and his crew by their zealous and unswerving work rescued some twenty-eight people from five different vessels during a great storm. In addition to the number of individuals rescued, the number of vessels involved, the weather conditions and the duration of their efforts, James and his crew conducted differing types of rescues which included the employment of the beach apparatus and rescue by boat. For their versatility, endurance, skill and dedication, James and his crew were awarded Gold Lifesaving Medals.

Priscilla *Rescue*

On August 18, 1899, Surfman Rasmus S. Midgett, from the Gull Shoal Life-Saving Station (North Carolina), was conducting a beach patrol on horseback and came upon the barkentine *Priscilla*, which had run aground. Given his distance from the station, he determined to do what he could alone. Immediately, he ran as close to the wreck as he could and shouted instructions for the men to jump overboard one at a time as the waves receded. Obeying his instructions, the sailors leapt overboard. Midgett seized each man and dragged him from the pursuing waves safely to the beach. In this manner, he rescued seven men. There were still three men onboard who were too weak to get off the vessel. Midgett went into the

water and carried each of them to the beach. For the ten lives he saved, Midgett was subsequently awarded a Gold Lifesaving Medal.

Keeper George N. Gray and the Charlotte (New York) Life-Saving Station (December 14–15, 1902)

The crew received the Gold Lifesaving Medal in recognition of their rescue of four men and one woman from the wreck of the schooner *John R. Noyes.* They were engaged for more than a day and a night with little sleep, having been under oars from 11:30 p.m. of the fourteenth to 4:30 p.m. of the fifteenth with the exception of about two hours. They pulled in a heavy seaway for nearly sixty miles and all were covered in ice and were frostbitten. In addition to the conditions and distances rowed, the keeper commandeered a train and sleds to move the beach cart and equipment through the deep snowdrifts for the launching of the surfboat.

Overland Rescue

In 1897, eight whaling ships were trapped in the Arctic ice near Point Barrow, Alaska. Concerned that the 265 crewmen would starve during the winter, the whaling companies appealed to President William McKinley to send a relief expedition. USRC *Bear* sailed northward from Port Townsend, Washington, in late November 1897. With no chance of the cutter pushing through the ice to Point Barrow, it was decided to put a party ashore and have them drive reindeer to Point Barrow. Lieutenant David H. Jarvis was placed in charge. He was joined by fellow officers Lieutenant Ellsworth P. Bertholf and Surgeon Samuel J. Call, along with three other men. Using sleds pulled by dogs and reindeer, snowshoes and skis, the men began the expedition on December 16. They arrived at Point Barrow, fifteen hundred miles later, on March 29, 1898. The expedition managed to bring 382 reindeer to the whalers, having lost only 66. For their work, Bertholf, Call and Jarvis received a gold medal from the United States Congress.

Bermuda Sky Queen *Rescue (October 14, 1947)*

The American-owned flying boat *Bermuda Sky Queen*, carrying sixty-nine passengers, was flying from Foynes, Ireland, to Gander, Newfoundland. Gale-force winds had slowed her progress and she was running low on fuel. Too far from Newfoundland and unable to make it back to Ireland, the captain decided to fly toward the cutter *Bibb*, which was on Ocean Station Charlie in the North Atlantic. The plane's captain decided to ditch and have his passengers and crew picked up by *Bibb*. In thirty-foot seas, the transfer was both difficult and dangerous. Initially the *Bibb*'s captain tried to pass a line to the plane as it taxied to the lee side of the cutter. A collision with the cutter ended this attempt to save the passengers. With worsening weather, a fifteen-man rubber raft and a small boat were deployed from the ship. The raft was guided to the escape door of the aircraft. Passengers jumped into the raft, which was then pulled to the boat. After rescuing forty-seven of the crew, worsening conditions and the approach of darkness forced the rescue's suspension. By dawn, improved weather allowed the rescue to resume and the remaining passengers and crew were transferred to the *Bibb*. The rescue made headlines throughout the country and, upon their arrival in Boston, *Bibb* and her crew received a hero's welcome for having saved all those aboard the ditched *Bermuda Sky Queen*.

1937 Mississippi Flood

During the disastrous 1937 Mississippi River flood, the Coast Guard rescued a total of 43,853 persons who they "removed from perilous positions to places of safety." Additionally, they saved 11,313 head of livestock and furnished transportation for 72 persons in need of hospitalization. In all, 674 Coast Guardsmen and 128 Coast Guard vessels and boats served in the relief operations. The immense scope of the operations actually eclipsed the number of persons that the Coast Guard rescued during the Hurricane Katrina operations.

Sources

Authors' note: You will notice a sparse bibliography. Most information came from personal interviews with Bernard Webber complemented by other sources listed below. Individuals who provided information used in the book are listed within the text.

Books, periodicals, articles, organizations, institutions, documents and
 Internet sources include:
Bloomberg.com
Boston Globe
Boston Herald
Cape Cod Times
Chatham Monitor
Deyo, Simeon. *A History of Barnstable County.* New York: H.W. Bake & Co.,
 1890.
E.G. Perry
The Humane Society of the Commonwealth of Massachusetts
kellscraft.com/RamblesBoston
kinghiramslodge.org
masslifesavingawards.com
New York Times
Orleans Historical Society

The Town of Chatham, Massachusetts

The United States Coast Guard

U.S.L.S.S. Living History Association

Webber, Bernard C. *Chatham: "The Lifeboatmen."* Orleans, MA: Lower Cape Publishing, 1985.

INDEX

Y

ABOUT THE AUTHORS

Theresa M. Barbo is Director of the Cape Wildlife Center, a program of the Humane Society of the United States, and the Fund for Animals. She is also the author of historical nonfiction books and is a former award-winning broadcast journalist, newsmagazine history editor and noted public lecturer. Published by The History Press, her works include *The Cape Cod Murder of 1899*; *True Accounts of Yankee Ingenuity & Grit*; and the previous two editions of *The Pendleton Disaster off Cape Cod: the Greatest Small Boat Rescue in Coast Guard History 2nd Edition* (co-authored with W. Russell Webster, which remains on the Commandant's Recommended Reading List for Leadership). Her other works include *Cape Cod Bay: A History of Salt & Sea, Foreword by Admiral Richard Gurnon, President, Massachusetts Maritime Academy*; and *Nantucket Sound: A Maritime History, Foreword by Congressman Bill Delahunt, 10th Massachusetts District*. She serves as chair of the Cape Wildlife Center Community Council and is a commissioner on the Cape and Islands Commission on the Status of Women. Theresa is the founding director of the annual Cape Cod Maritime History Symposium, partnered with the Cape Cod Museum of Natural History, now in its fifteenth year. She presents illustrated lectures on maritime history and contemporary marine public policy before civic groups and educational audiences. Her area of expertise in merchant marine research is on nineteenth-century Cape Cod sea captains when American deep water skippers ruled global maritime commerce.

She holds bachelor of arts and master of arts degrees from the University of Massachusetts Dartmouth and has studied executive integral leadership at the University of Notre Dame.

Theresa resides on Cape Cod with her husband, Daniel, and their children, Katherine and Thomas.

—◦◦◦—

W. Russell Webster retired from the U.S. Coast Guard in 2003 after serving twenty-six years' military service. While in the Coast Guard, Webster was Group Woods Hole rescue commander from 1998 to 2001 and led his service's operational response to the John F. Kennedy Jr. and Egypt Air 990 crashes. He was also the Coast Guard's regional operations officer for the September 11 terrorist attack responses. Captain Webster is a maritime historian who specializes in Cape Cod–area rescues. His current project is a new book that analyzes three milestone near-shore rescue cases in Coast Guard history: the 1990 *Sol e Mar* case, the 1997 *Morning Dew* case and the 2009 *Patriot* sinking. Captain Webster is providing a historical narrative of these three tragedies and suggesting changes based on common themes that have emerged from his investigation.

He is a graduate of the U.S. Coast Guard Academy, Naval Postgraduate School in Monterey, California, and the Naval War College in Newport, Rhode Island, and holds a master of science in systems technology and a master of arts in national strategic studies. Webster is New England's first Preparedness Coordinator for FEMA in Boston, where he coordinates with states, communities and individuals to better prepare for both man-made and natural disasters. He resides in Cape Elizabeth, Maine, with his wife, Elizabeth, son Andrew and daughter Noelle.

—◦◦◦—

Master Chief John "Jack" Downey's last assignment was command master chief First Coast Guard District from June 2006 to June 2008. His primary responsibilities were to advise Rear Admiral Timothy S. Sullivan, commander of First Coast Guard District, on issues and initiatives

pertaining to all Coast Guard members and their families within District One. The First District includes eight states in the Northeast and 2,000 miles of coastline from the United States–Canada border to northern New Jersey. Master Chief Downey entered recruit training at Training Center Cape May in November 1966; he has served continuously in the Coast Guard for over 40 years in Reserve and active duty status. Master Chief Downey is the first recipient of the Joshua James Keeper Award (Ancient Keeper). Master chief held this distinguished title of Ancient Keeper until he retired. The Joshua James Keeper Award recognizes longevity and outstanding performance in Coast Guard Boat Forces operations. The award's namesake, Captain Joshua James, saved 626 lives and is the most celebrated lifesaver in Coast Guard history. Master Chief Downey has held the title of officer in charge of Boat Forces units for more than 17 cumulative years and has served in the Boat Forces community for more than 20 years.

Master Chief Downey has served in a wide variety of operational, command and staff assignments; five officer in charge multimission ashore assignments; and two officer in charge afloat assignments, aboard CGC *Towline* and CGC *Hammerhead*. Other afloat assignments are the CGC *Casco*, CGC *Chase* and CGC *Cape George*. Master Chief Downey also served temporary duty assignments aboard CGC *Seneca*, CGC *Reliance*, CGC *Neah Bay* and CGC *Point Hannon*. Early in his career he was assigned to Coast Guard Air Station Salem as a crewman aboard a rescue and recover craft for water takeoff and landing of Coast Guard aircraft. Staff assignments were chief in the barracks for Gulf Company and lead instructor for the Command and Operations School at the Leadership and Development Center located at the Coast Guard Academy in New London, Connecticut. Master Chief Downey's personal awards include the Legion of Merit, Meritorious Service Medal with a gold star and operational distinguishing device, Coast Guard Commendation Medal with three gold stars and operational distinguishing device, Letter of Commendation with operational distinguishing device, Good Conduct Medal with a silver star and the Navy League Douglas A. Munro Award for inspirational leadership. Jack and his wife, Judith, reside in Narragansett, Rhode Island, where he is now the Narragansett harbormaster.

Visit us at
www.historypress.net